8/95.

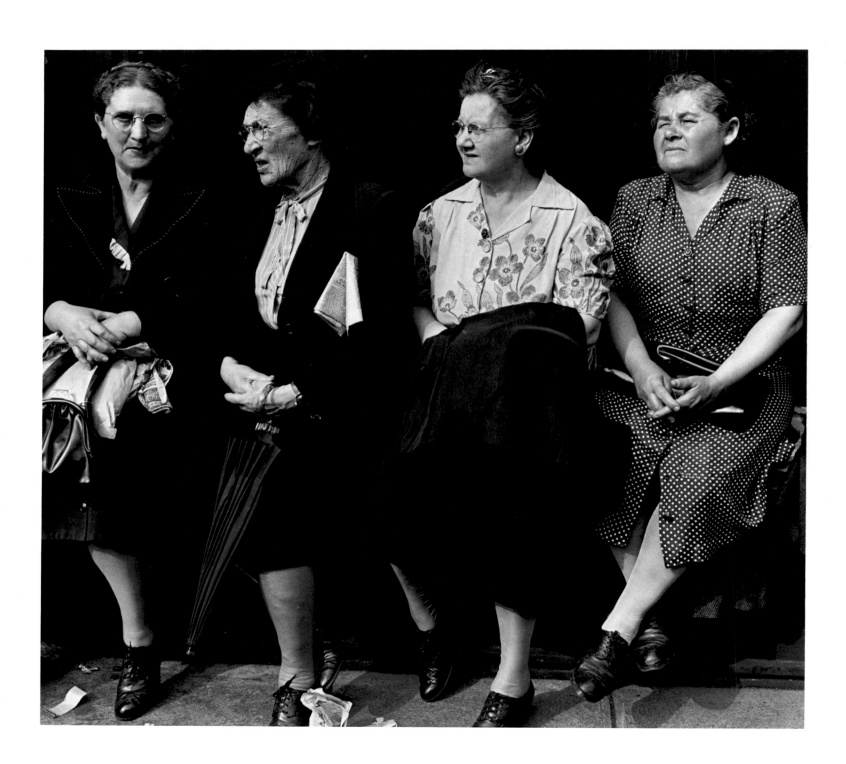

New York City, 1947

the people, yes

Photographs and Notes by

JEROME LIEBLING

Foreword by

CARROLL T. HARTWELL

Introduction by

KEN BURNS

APERTURE

Foreword

Beginning with his earliest photographs, made in the late 1940s, Jerome Liebling's work has been an important part of the tradition Walker Evans referred to as the "documentary style." This broad category includes the work of Evans himself, Eugène Atget, Lewis Hine, Russell Lee, Dorothea Lange, W. Eugene Smith, and many others, all committed to an agenda of objective description of people, places, and things. These photographers shared an abiding confidence in the meaning and eloquence of the subject itself.

Documentary photography, as defined by Evans, must evoke a sense of the photographer's personal values and his or her distinctive insight. The photographer's success is based upon his or her ability to convey this sense of human vision that touches us immediately, at the heart.

Liebling's work, then, makes its place in the history of photography at the intersection of the expressive and the documentary. His focus is remarkably consistent: he photographs a full range of gestures, ages, and circumstances. Most importantly, in his pictures—even when there is no person visible—the human presence is felt. But to call him simply a photographer of people would be misleading. During the course of his long career, Liebling has developed and honed a remarkable capacity for discovering and capturing meaning in all manner of subjects. The signature of his unique vision is its eloquence, its profound lyricism.

The aesthetic and moral values of former mentors continue to echo, however subtly, in Liebling's sensibility. His mentors were some of the most respected names in a generation of photographers: Paul Strand, Walter Rosenblum, Lewis Hine, and other members of New York's Photo League (where Liebling, too, was a member in its final years). The League was his ethical and artistic crucible, charged with the intense energy and talents of those extraordinary individuals.

Liebling has in turn evolved as a mentor. During the course of his long teaching career—at the University of Minnesota, Hampshire College, and Yale University—he has inspired an entire contingency of students, who remain devoted to him: many have gone on to careers as highly respected photographers and filmmakers in their own right. Liebling is a rare kind of teacher, who produces not proselytes or disciples, but creative, free-thinking individuals, with distinct ideas and styles. In his introduction to the 1983 exhibition catalog "Light of Our Past: Minnesota Photographic Heritage, 1947–1974," James Dozier wrote:

When I first met Jerome Liebling . . . I was impressed with his humanism and deep commitment to photography. I was also struck by the number of Liebling's former students who still live in Minnesota and who feel a bond with him.

What is remarkable . . . is the number of committed photographers who emerged and the diversity of the photographic styles they have developed.

Dozier is describing a lineage that connects Liebling to his students at the University of Minnesota, and places him as the generative fulcrum of serious photographic activity and community in Minnesota. But more broadly, in this same genealogy, Liebling is the link between those students—a generation of midwestern photographers—and the Photo League of 1940s New York.

This publication is designed and structured to discover the primary passages, or "chapters," in Liebling's work. The accompanying exhibition, which opens at the Minneapolis Institute of Arts and travels to London's Photographers' Gallery and other venues, likewise follows these thematic currents. We journey from the black-and-white urban vignettes—some of Liebling's earliest photographs—to the art, politics, and poetics of New England, seen in lush and dynamic color. We are drawn to the sheer beauty of the nudes and the farm-scenes, only to be shocked—even repelled—by the cadavers and the slaughterhouses. The work moves from light to dark and back again: the photographer's empathy encompasses an astonishing gamut of experience.

This empathetic sensibility takes hold, even in those images we may at first find difficult to look at: all of his photographs speak to us and draw us in. With compassion, humor, and great insight, Liebling locates and celebrates the day-to-day valor of humanity. His personal vision and wisdom are the substance and soul of the images; they form the central cord of his remarkable life's work.

CARROLL T. HARTWELL
Curator of Photography,
The Minneapolis Institute of Arts

Freedom of Thought
Jerome Liebling as Teacher

BY KEN BURNS

When our complicated republic was first born, it was graced with the talent, energy, wisdom, and foresight of many remarkable individuals who have in the years since been somewhat obscured under the deadening rubric "founding fathers." But they were just that: men who not only gave voice to our political and social and even spiritual intentions, but served as mentors for the following generations of leaders in arts, literature, and music, as well as in politics and the law.

The words of these men are their finest legacy—the DNA of our present civilization, encoding the best of us for posterity. Their letters reveal such startling brilliance, honor, and compassion, that we may feel a little bereft today—lacking, as we do living in our consumer society, real heroes and mentors of this stripe. Throughout their writings, we find these people warning each other constantly about *ambition*. Not to have it. To be aware of those who do. To lament its influence in the course of the affairs of men. Today we've deemed ambition a good quality, but for these extraordinary individuals, ambition was seen as simply selfish advancement, disconnected from personal and professional honor, community responsibility, and the obligations of virtuous and spiritual existence.

Today ambition is the jet-fuel of our get-ahead world; then it was a toxic by-product of a soul not yet touched by what a later political leader, Abraham Lincoln, would call "the better angels of our nature."

I bring this up by way of introducing Jerome Liebling, my own mentor. He is an extraordinary man, free of ambition yet possessed of the same dignity, honor, and integrity that has informed the work of the greatest among us, no matter the field. The following is adapted from remarks I gave in 1990, on the occasion of Jerry's retirement from full-time teaching.

Twenty-five years ago this fall I filled out an application to attend a brand-new institution of higher learning—Hampshire College. I was then a seventeen-year-old high-school student, and Hampshire, with its radical departure from traditional educational models, seemed an answer to all my prayers. I knew only one thing then with a burning certainty: I wanted to make films. I wanted to be the next John Ford or Howard Hawks or Alfred Hitchcock. For years I had lived in revival houses, soaking up the classics, thrilling to the new wave of French, Italian, and Japanese films. And I read, with almost no comprehension, everything I could find: dozens of books on film history, theory, and criticism. I was sure Hampshire College and its professor of film and photography—Jerome Liebling—would help me unlock the secrets of this medium and show me what I knew I needed most: how to *make* feature films in Hollywood.

It is funny how you remember, as clearly as if it were yesterday, things from those naive days. For me, my burning desire to *know* and to *understand* came down to one sentence, in one review of one film director by one film critic. I could not understand what this sentence meant and I vowed that I would go to Hampshire, confront this Jerome Liebling, and find out what it meant. If I did—if I could divine the meaning in this one complex and, to me, indecipherable sentence—the whole of film would be clear. The line came from a book I knew almost by heart: *The American Cinema* by Andrew Sarris. He was then the critic of the *Village Voice* and the most prominent American proponent of the controversial "auteur theory." He was famous for rating Hollywood directors, demoting a lot of famous ones, and elevating other, more or less obscure ones. My sentence, which I committed to memory, and still know by heart today, was about the director Nicolas Ray and his film *Johnny Guitar*, which was written by a man named Philip Yordan.

In the fall of 1971 I set off to Hampshire College, found Jerome Liebling, and enrolled in his class. I waited for the right moment, when I had him alone in his office, explained my situation and the meteoric path I had charted for myself in Hollywood, and then begged him to explain what my sentence meant. I thought I understood everything Sarris said about Nicolas Ray and *Johnny Guitar* and Philip Yordan, except for the *last* frustrating sentence in the piece. Liebling, who was at that time quite a scary and imposing figure for us neophytes, sat impassively as I framed my question. At last I came to the supreme moment and I blurted out my hieroglyphics. "Okay," I said. "This is what Sarris says: 'Philip Yordan, in *Johnny Guitar*, set out to attack McCarthyism, but Ray was too delirious to pay any heed as Freudian feminism prevailed over Marxist masochism and Pirandello transcended polemics.'"

Jerome Liebling—the man who was supposed to explain the mysteries to me, the man who would be the key to my future, the man I hoped would be my mentor—just looked at me and stared. I can remember his look as if it just happened today. Jerry slowly and gently rose from his chair, took me by the elbow (as he still does) and led me politely and firmly from his office. I don't remember what he said; that look had said it all. And as I stood alone outside his office, contemplating suicide, I decided to go into anthropology.

It is funny that, nearly twenty-five years later, I am no closer to Hollywood and I still don't know what that sentence meant. Only now I don't *want* to know. I have had an incredibly enriching life making documentary films and there is one chief reason for that: Jerry Liebling. He *did* explain the mysteries, he *was* the key to my future, he was and is my mentor, and that recognition is as sublime to me today as the horror and humiliation of that scene long ago.

Jerry never answered my question, he just quietly disenthralled me from my burdensome, overly intellectual approach, and moved us all on to a discovery and appreciation of the drama that exists not in Hollywood and the imagination, but in the myriad heroic acts of merely being on this planet. He opened us up, whether in film or photography (and you must realize how rare it is in this country to teach film and photography under one roof), he opened us up to this heroism in a passionate, twenty-four-hour-a-day style.

I know I took many many classes in college, but what I remember most of those four years was taking the same course over and over again: Advanced Film and Photography. The class met all morning

or all afternoon; some semesters it met all day. Filmmakers showed their rushes to photographers, photographers pinned up their freshly dried prints to hear us filmmakers massacre their private vision. And all the time, underneath, was the quiet bass note of Jerry's careful criticism and commentary, building you up when the problems and inevitable ruts of exposing yourself in work got to be too much, and tearing you down when the equally inevitable hubris and overconfidence set in. I can remember *knowing* what I did was good, but Jerry still didn't like it, because the person inside me, the *genuine* part of me, hadn't done it. Or else the product—perhaps a short film or freshman attempt at still photography— was more greed than desire.

Many fell away. Film and photography were always popular and dozens sought to get into the classes and cruise along. I particularly wanted to be shown technique and style and how to operate a camera and how to take light readings and when was the right moment for a closeup. But Jerry never told me, never told us these things. Formula did not exist. Technical information was best discovered out in the field, through trial and error: a wonderful and very simple way to weed out those who were not absolutely serious.

Jerry taught us to respect the power of the single image to communicate, whether in film *or* photography. And to communicate without undue manipulation. This has proved extremely valuable in my own work as I seek to divine some meaning from the past in old documents, paintings, faded and yellowed newspaper clippings, first-person quotes, music, photographs, newsreel. The truth is in the image, not in some artful (or as Jerry would say, "arty") manipulation of those images.

We looked at photographs. Constantly. We went to shows in Boston and New York. Invited people to come and see us and tell us what they were thinking and show us their work. He demanded that we filmmakers use the honorable practices of still photography—respect and concern for the subject, strong composition and formal appreciation, and dynamism within the image. Many documentary makers have long sought to explain the absence of these elements with the feeble excuse that just getting the scene on the fly is all that is possible and good enough. For Jerry there could be no such excuses, and if you look at the work of his film students you will see strong composition, sensitivity and care for subject matter, a sense of history and time, images that suggest a life and reality before and after their moment.

Jerry taught indirectly—I'm convinced it is the only way to convey real knowledge, lasting knowledge, *non satis scire*–brand stuff (Hampshire College's motto: "to know is not enough"). And he taught through real relationship: to a place, to a subject and *with* his students. It is no accident that so many of us not only keep in touch with Jerry, but twenty years later count him as a close friend, for many of us, as family. The message, his message, came and accrued over time, like layers building up on a pearl. And this required more than a classroom relationship with a man who was also struggling with his own work, his own questions, his own demons.

And the imparting, the teaching went on all the time. I remember Jerry would call and say, "What are you doing? My car is broken down and I need to go to Northampton to shop and drop off laundry." So we would go and spend the afternoon doing nothing, having a bite to eat, running errands. I always came back from these trips elated. Jerry was always looking, pointing out the frieze on a heretofore unnoticed

commercial building, pointing out the lines of things, snapping a picture of someone along the way with a directness and a kind of confrontation that wasn't violent but loving and accepting. I came to live for those trips, though I can hear Jerry say even now, "Jesus, I just wanted a ride to the laundry."

He encouraged us filmmakers to set up our own film company in school, called Hampshire Films. It was an entirely practical and Lieblingesque solution to the problem of willing students, some equipment, and *no* money to make films. We got nonprofit companies in the valley to hire us at no wages to make documentary films at cost. They got more or less accomplished films where they would not have been able to afford them. And we got practice. At our art, but also at proposal writing, public speaking, bookkeeping. I even learned how to tie a tie. It made it possible to leave Hampshire and have the confidence to start my own company and not spend years mired in someone else's vision of things.

The relationships that Jerry asked us to see, the questions he forced us to confront, the material he exposed to us went way beyond the classroom. He seemed to be working on the *whole* of us, and I know this is true for other former students of his because we still talk about it among ourselves. It was a critical relationship; in the early years of our work we lived for his approval. We existed as a subset of his beliefs and values. And then, slowly, the miraculous started to take place. We began to grow on our own. We began to have our own questions, we began to develop our own styles.

I remember a moment late in my years at Hampshire when Jerry and I were alone in a dark editing room looking at an emerging film of mine. It was still a rough cut, still had a long way to go, and many problems were unresolved, but I was moving forward and sharing it with Jerry. He had been instrumental in nearly every approach I had taken, showing and reminding me of ways of filming things far beyond close-ups and wide shots, and I had taken it all to heart. We were disagreeing over something—I don't remember now what it was—but before then I would have yielded to Jerry because there was nothing in me that had force. This time, though, I held my ground. No, I wanted to do it this way, I was sure that was right. In one amazing instant I watched Jerry back off, just slightly. He didn't stop disagreeing with me: he only backed off the slightest degree. And in that instant, I knew he had let me go. That I was on my own in a way I had not been before. I realized that this had been a true master-student relationship. That the greatest gift Jerry had given me, given us all, was a real, not artificial, freedom.

Finally, I cannot neglect talking about what most of you know of Jerome Liebling, and that is his work. Perhaps more than any other element, we always had Jerry's work to teach us. Can you imagine the effect of those cadaver pictures on a raw nineteen year old? Can you imagine what the heroic force of those handball players did to my heart back then? I have mentioned Jerry's sense and ability to represent the terrible and poignant heroism of just being on this planet. Of being a cadaver, of being a handball player, a South Bronx teen, a slaughtered cow, a zucchini in a Hadley field, a Shaker dress. Can you imagine having *that* up on the wall next to your own work?

These pictures and this man will always be teaching, and therefore he will always be my teacher— because he wakes me up.

These days it seems that physical "truth" can easily be rearranged, rethought, or re-created outright. Any image can be made pristine, all the warts can be removed.

But returning to the source of a thing—the real source—means the photographer has to watch, dig, listen for voices, sniff the smells, and have many doubts.

My life in photography has been lived as a skeptic.

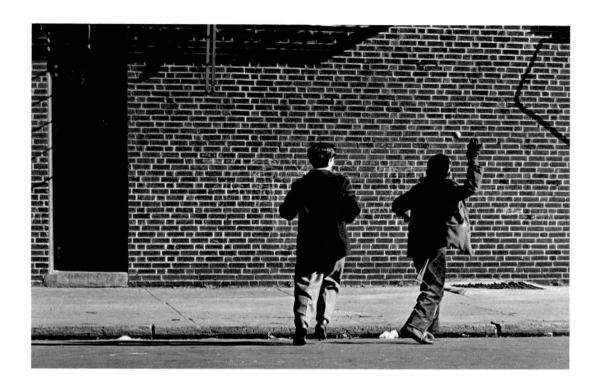

Handball, Brooklyn, New York, 1946

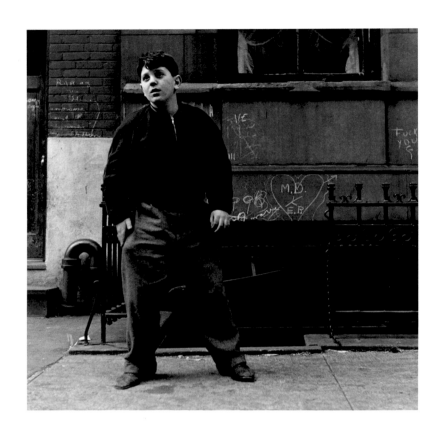

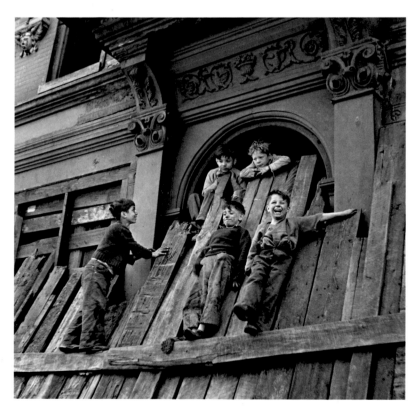

Top: *Young Boy, New York City, 1949*
Bottom: *Children, Abandoned House, New York City, 1949*

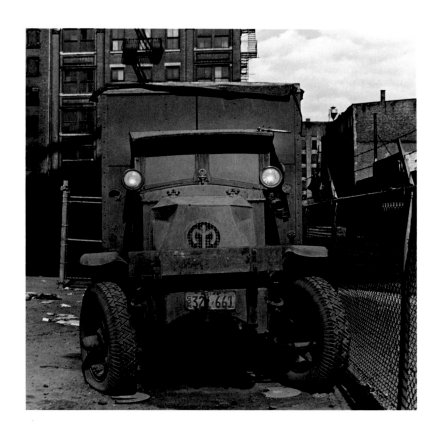

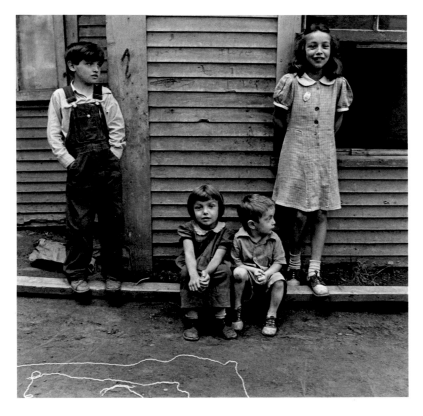

Top: *Truck, Manhattan Bridge, New York City, 1949*
Bottom: *Vermont, 1949*

13

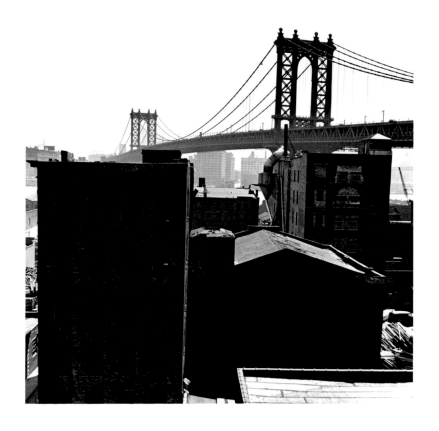

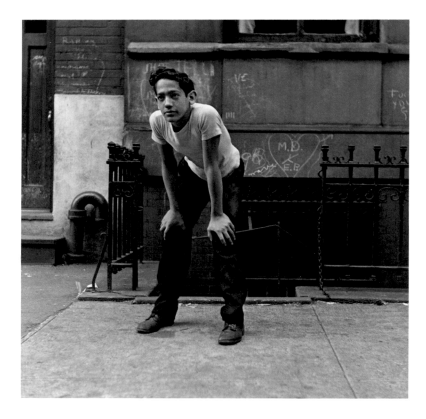

Top: Manhattan Bridge, New York City, 1949
Bottom: Young Boy, New York City, 1949

14

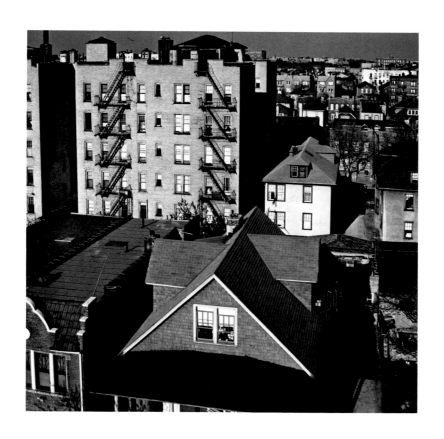

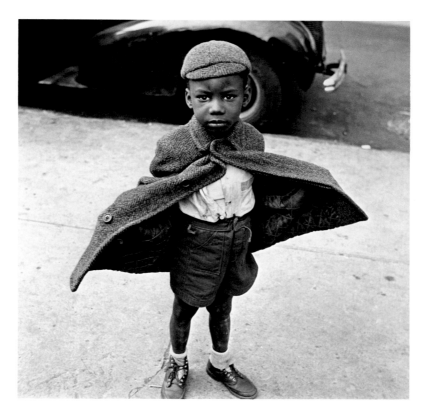

Top: *Brooklyn, New York, 1947*
Bottom: *Butterfly Boy, New York City, 1949*

15

In 1947 I joined the Photo League. Still a student at Brooklyn College, I was filled with ideas and ideals about documentary photography, the Bauhaus aesthetic, photo-journalism, filmmaking, and how all of this related to politics. The League was made up of many like-minded people, and gave great support to my photographic growth.

I met Paul Strand through Walter Rosenblum, who taught at Brooklyn College. I was impressed with the ideas both men represented. Rosenblum led me through the streets and helped me to establish where my sympathies would lie. Strand had such extra-ordinary integrity and meaning in his vision—for me, photography as a medium was made richer, more complex by Strand's work. His films also had an impact on me, and were part of what led me to enter film school in New York in 1948.

The influence of both Rosenblum and Strand gave my early photographs more dimension, stronger integration, and gave me—in all my work—a deep concern for the tension created in combining plasticity and meaning.

There was always an active dialogue at the League, which was carried out by some remarkable minds: W. Eugene Smith (who was president of the League in the mid forties), Dan Weiner, Sid Grossman, Aaron Siskind, Lisette Model, Arnold Newman, Weegee, and Ylla. In the company of such photographers, I learned to think about photography.

The League was wonderfully rich with challenges for the photographer, and part of its role, as Nancy Newhall said, was as "a testing ground for values . . . in the face of the blandish-ments of the commercial world . . . [it engendered] a movement of progressive humanity."

This is how I began to find my way, with images of people, where they lived and worked. My sympathies have always been with the everyday people; they are at the center of my photography.

Opposite: *Man and Visor*, Florida, 1981
Page 18: *Woman and Fur Jacket*, Brighton Beach, New York, 1982
Page 19: *Two Teenage Women*, Brighton Beach, New York, 1982
Page 20: *Man at Store*, Brighton Beach, New York, 1992
Page 21: *Woman and Red Coat*, Brighton Beach, New York, 1990
Page 22: *Women on Bench*, Miami Beach, Florida, 1985
Page 23: *Campers, Camp Taconic*, Hinsdale, Massachusetts, 1980

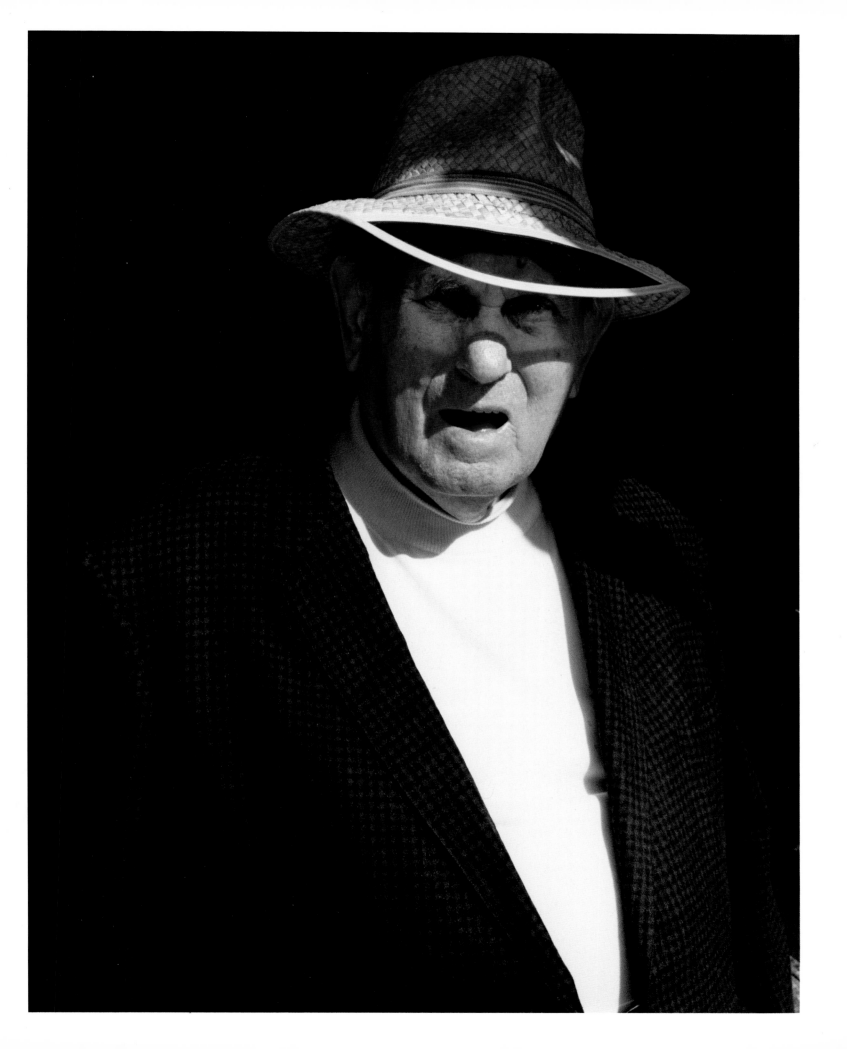

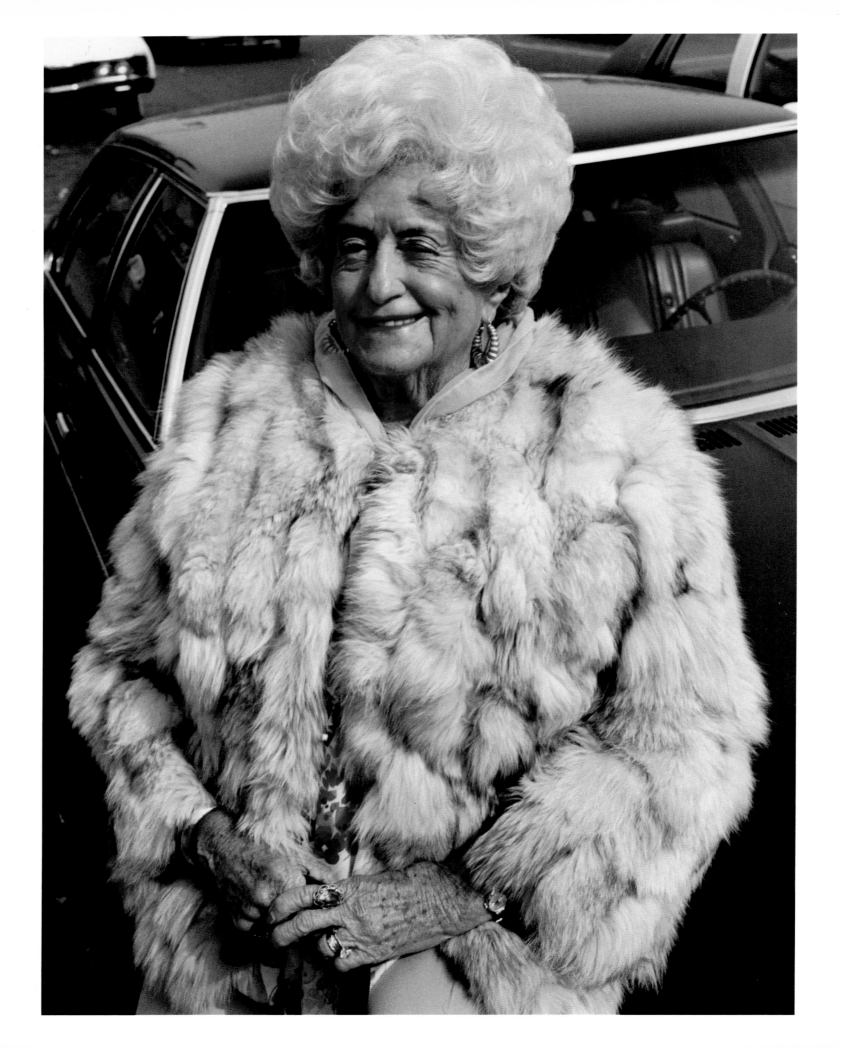

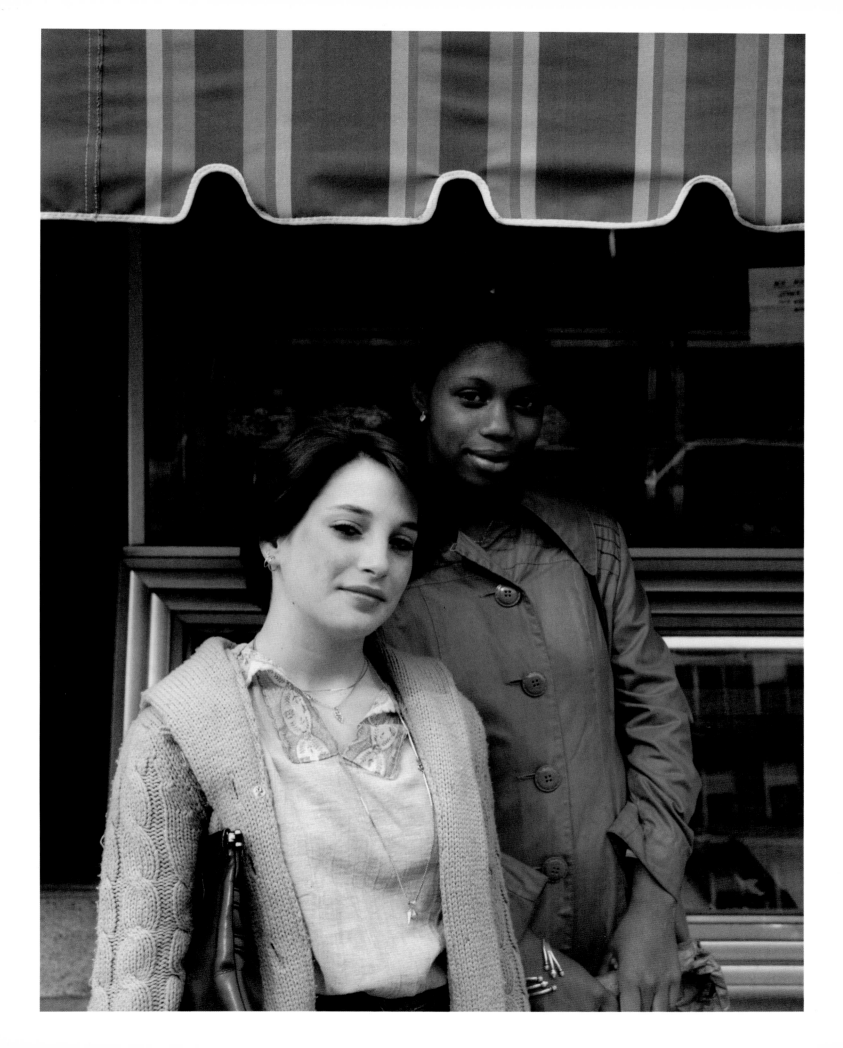

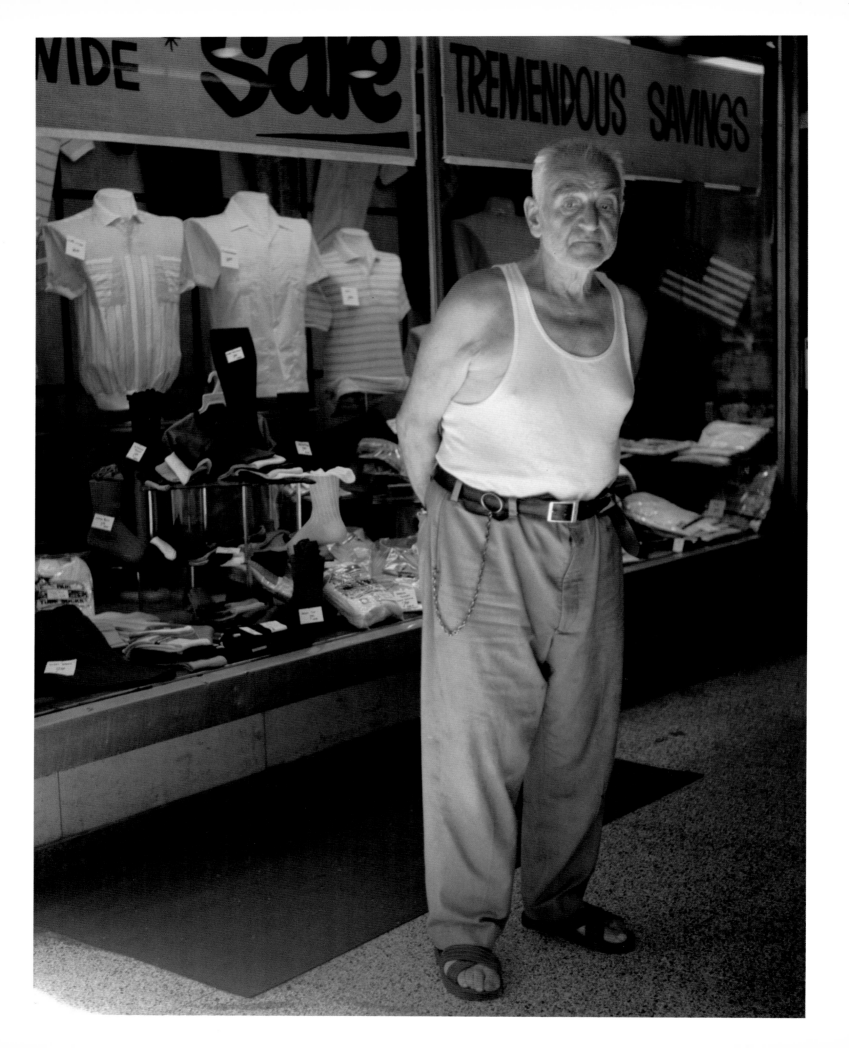

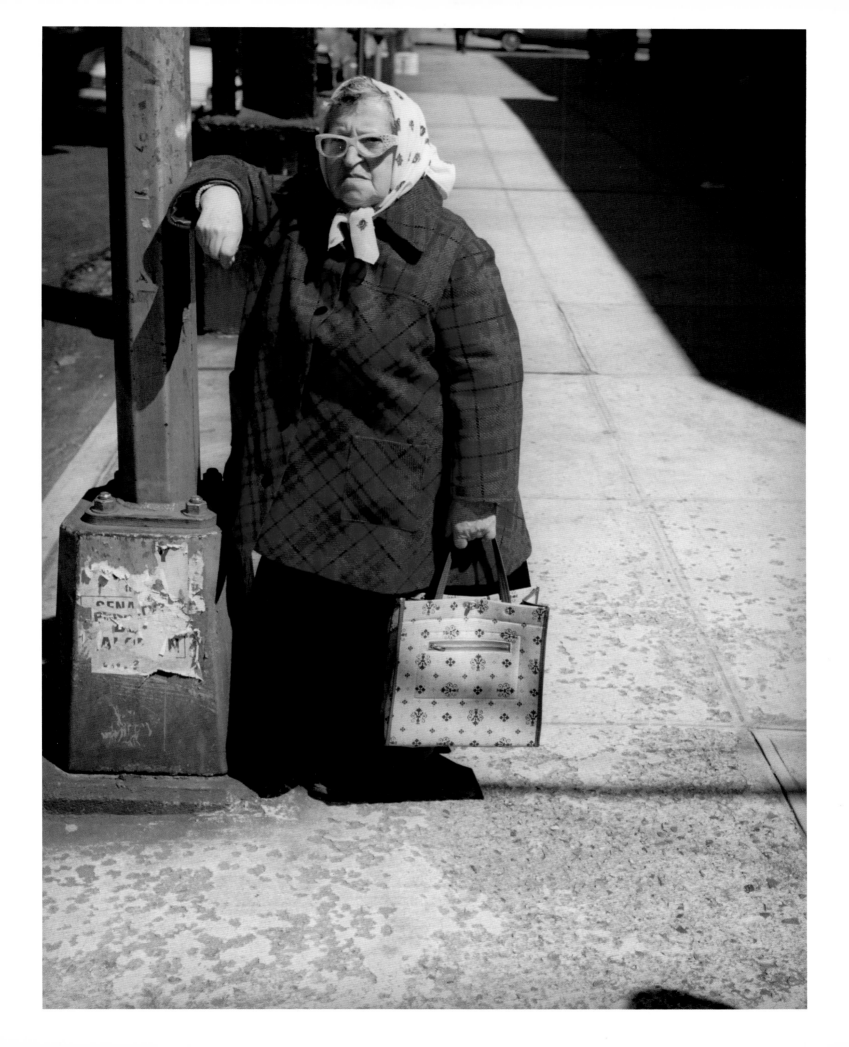

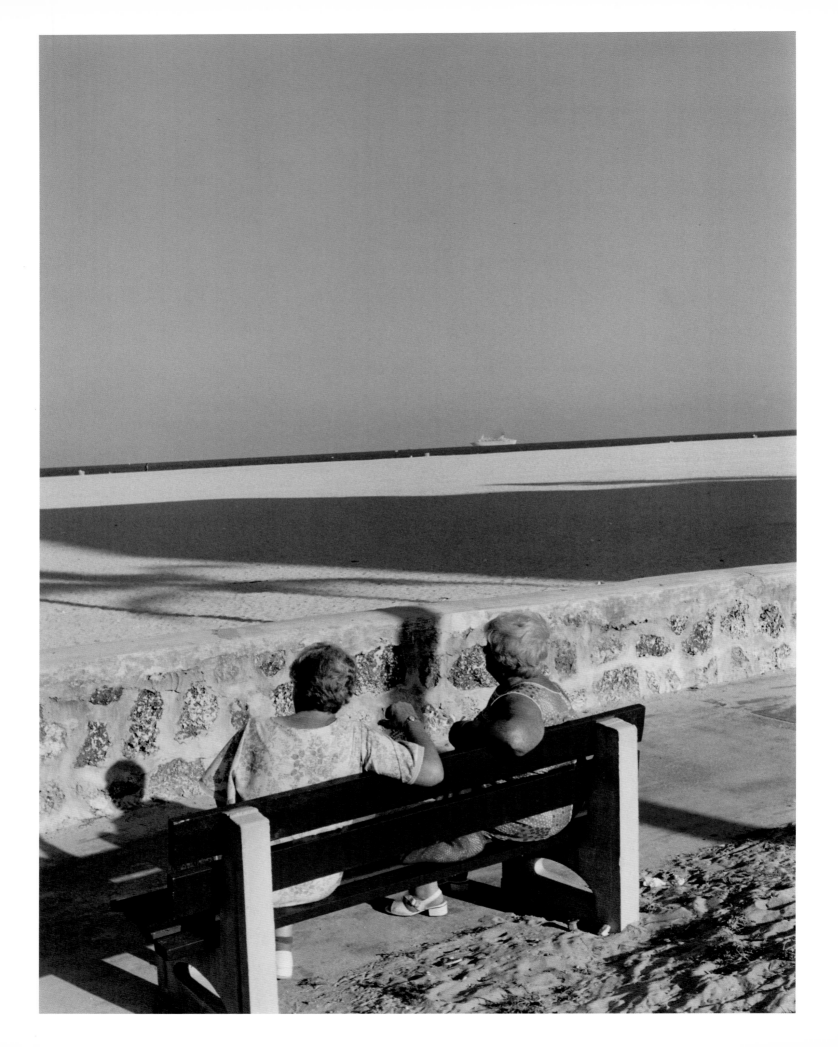

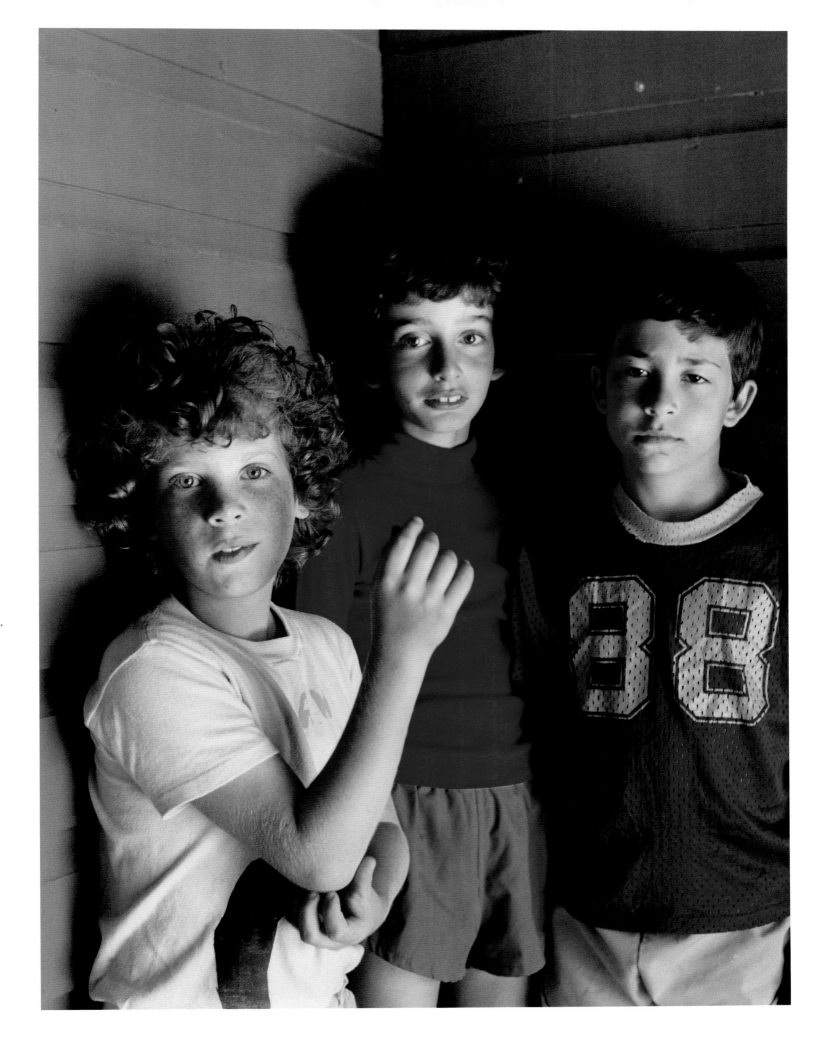

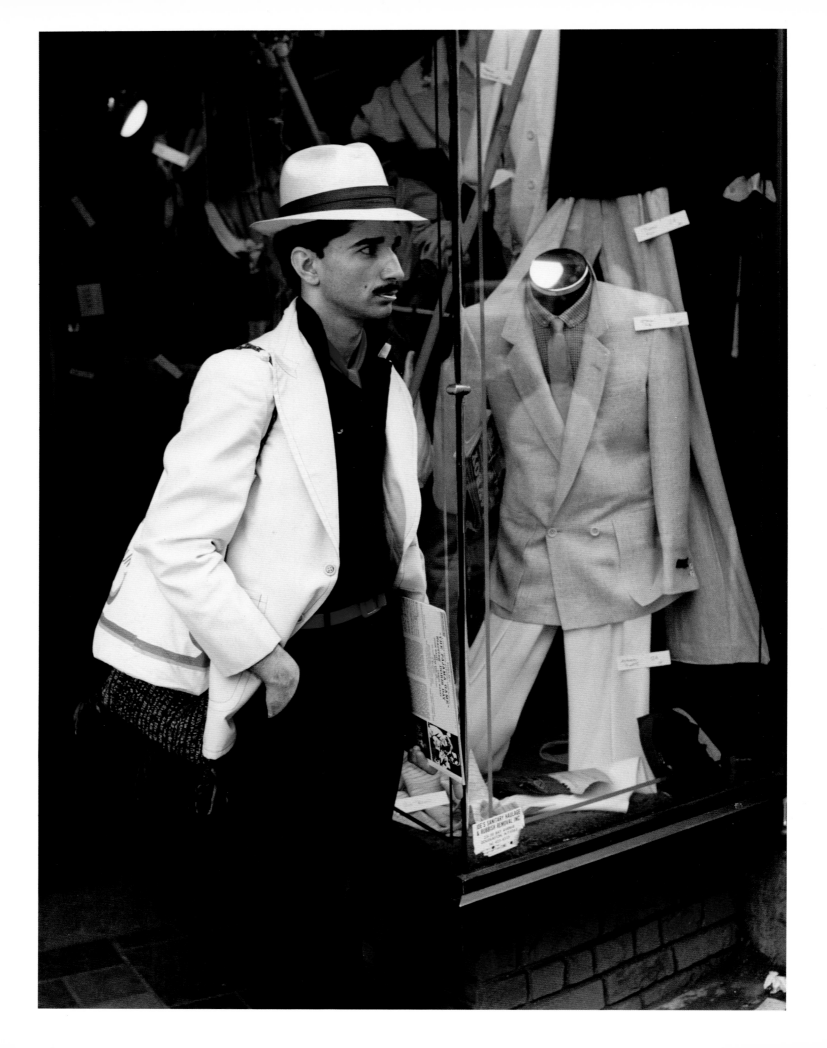

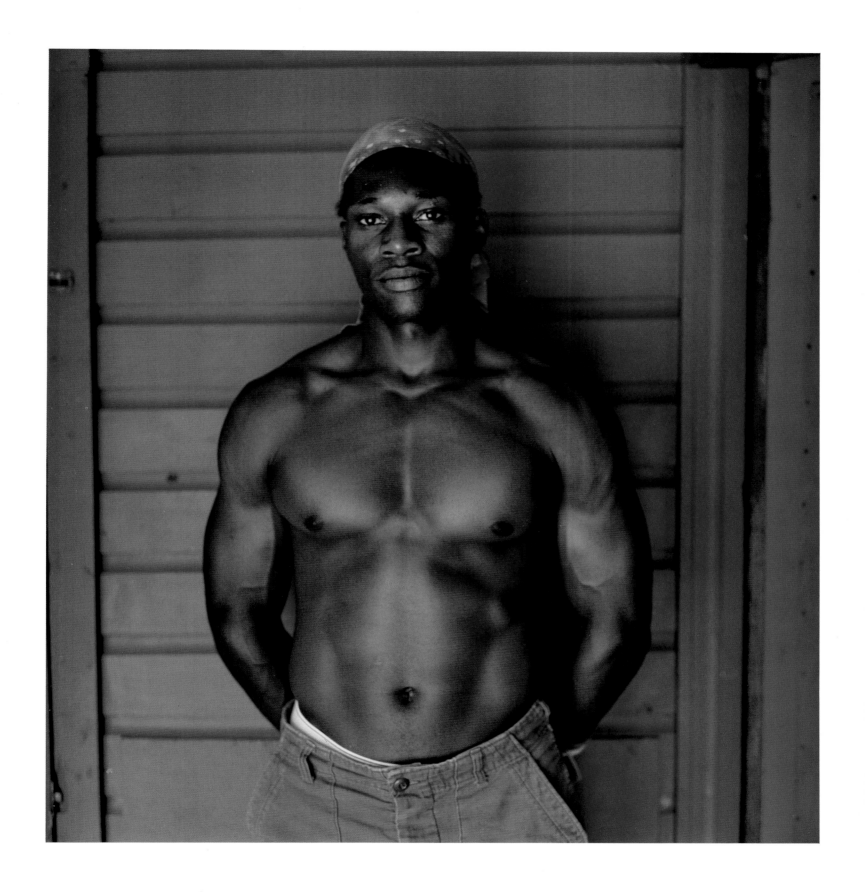

Opposite: Man with White Jacket, Brighton Beach, New York, 1981
Above: Counselor, Camp Taconic, Hinsdale, Massachusetts, 1980

New England is where I live: it is a place charged with the heritage of Americans—if there is such a commonality. This heritage originated and continues to evolve through politics and through rebellion.

Sorting through the past, I find that to my mind, those in power don't generally rate very highly: my sympathies are with the upstarts and protesters—with Thoreau, with Emerson, for their ideals and tenacity. Yet there is also an inevitable noblesse oblige: I defer to the Isabella Stewart Gardner Museum and the Fogg—even while I have always sided with Sacco and Vanzetti.

Many of these photographs were taken at places of historical importance. In the pictures, I've tried to weave the past together with the present. Certain ironies arise in this interweaving: Walden Pond is now a bathing park; the patriots, politicians, and protesters are now dressed in jeans at the town hall or on parade at the town common. The photographs introduce the contemporary to the echoes of history.

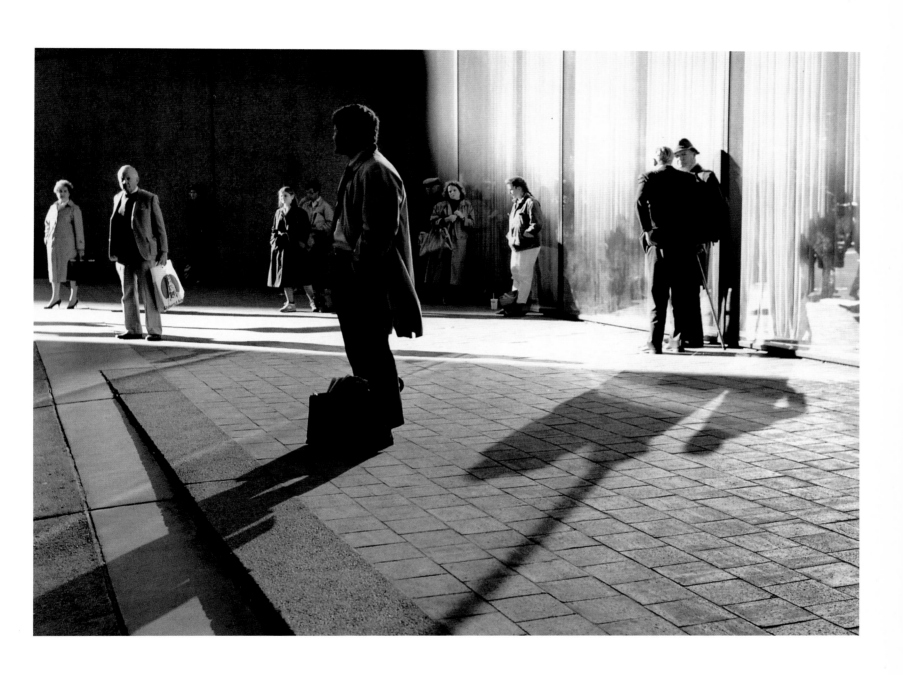

Boston, Massachusetts, 1984

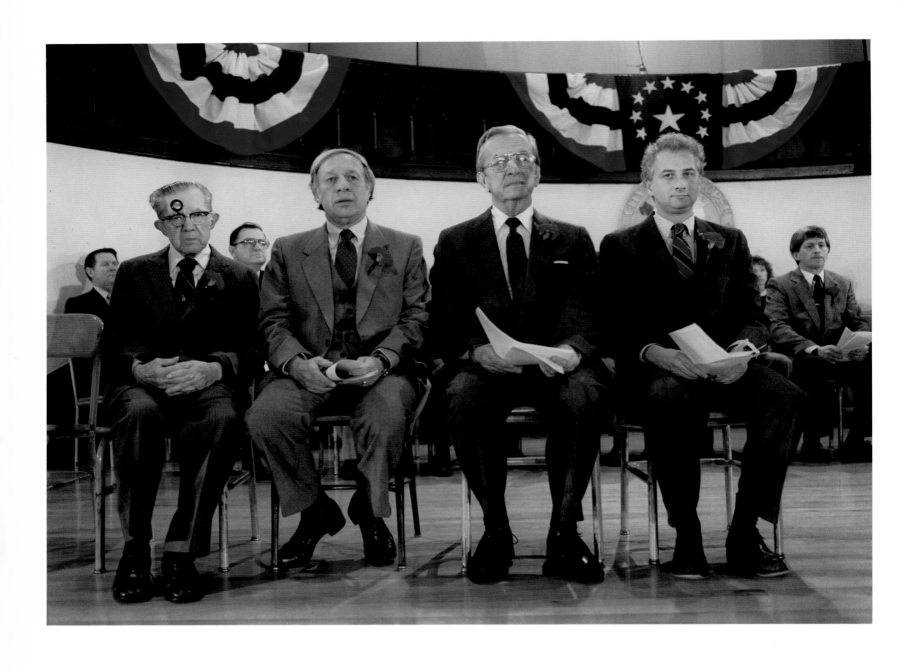

Mayoral Inauguration, Chicopee, Massachusetts, 1986

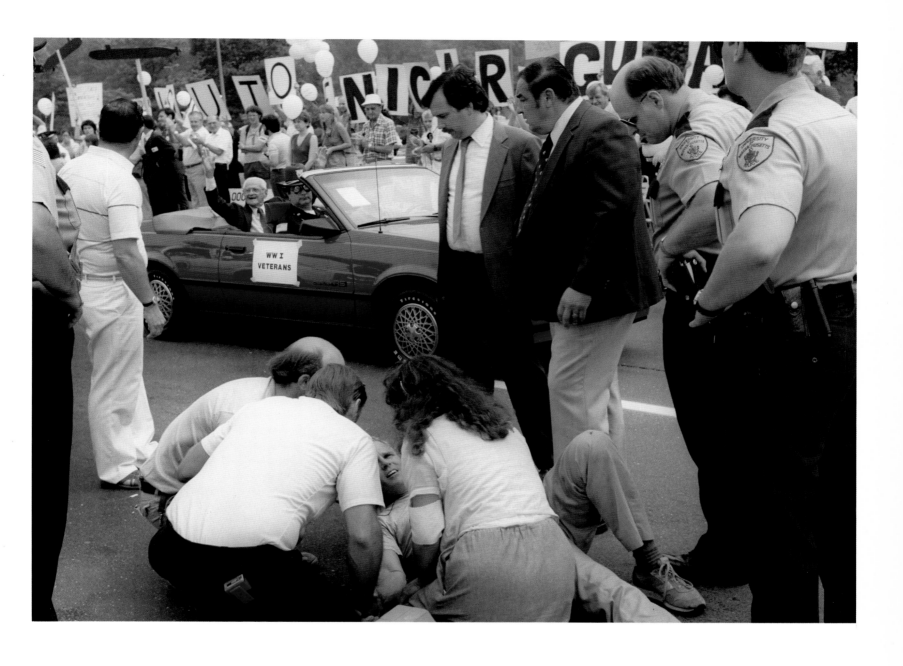

Demonstration, University of Massachusetts, Amherst, Massachusetts, 1986

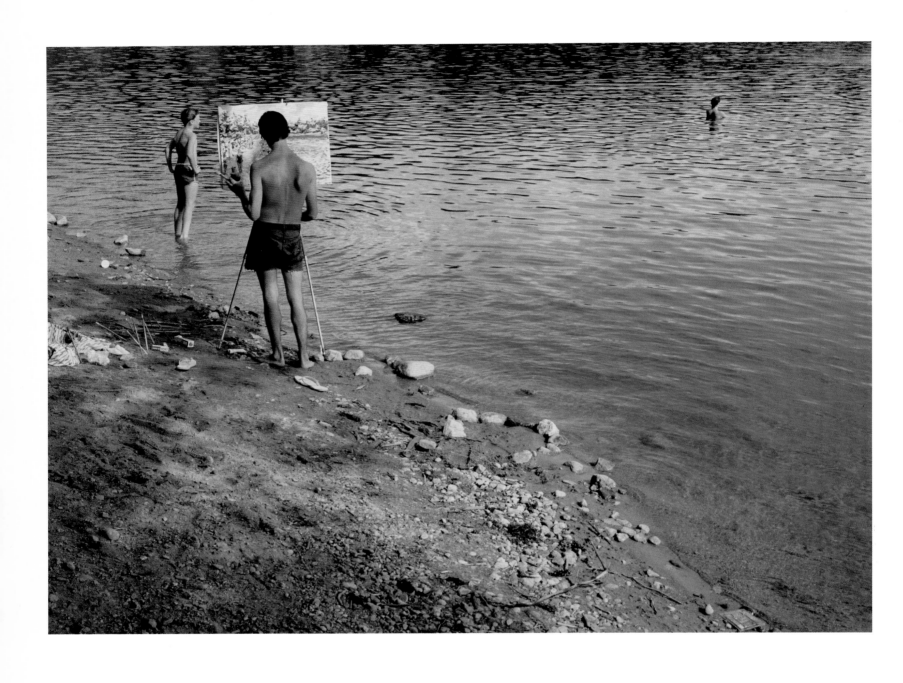

Walden Pond, Concord, Massachusetts, 1985

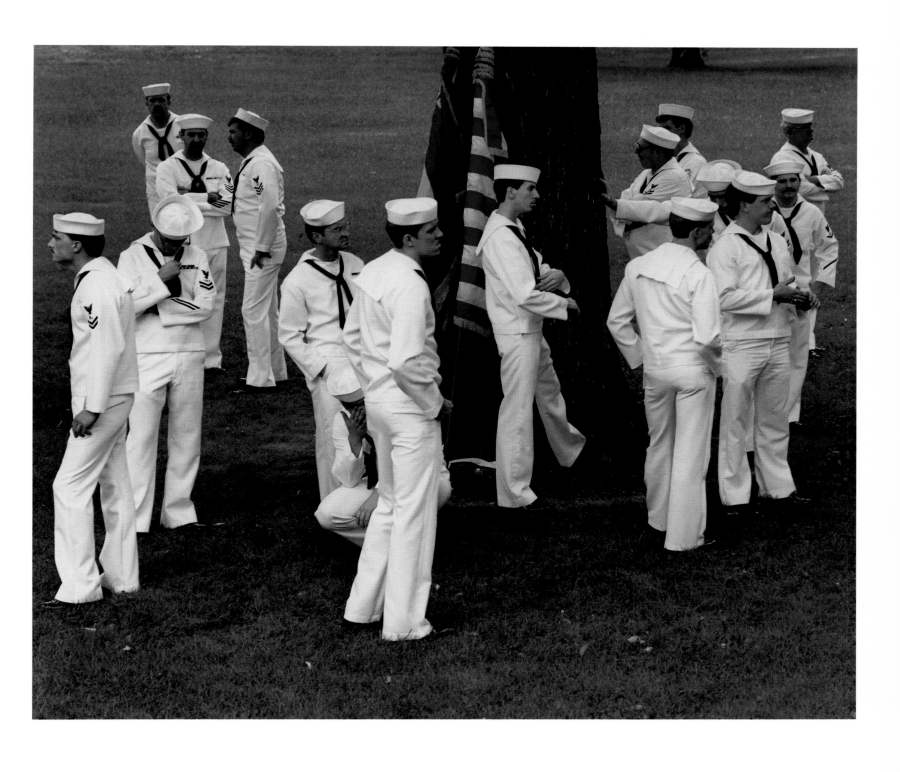

Sailors, Fourth of July Celebration, Amherst, Massachusetts, 1985
Page 32: *Isabella Stewart Gardner Museum*, Boston, Massachusetts, 1985
Page 33: *Fogg Art Museum*, Cambridge, Massachusetts, 1986

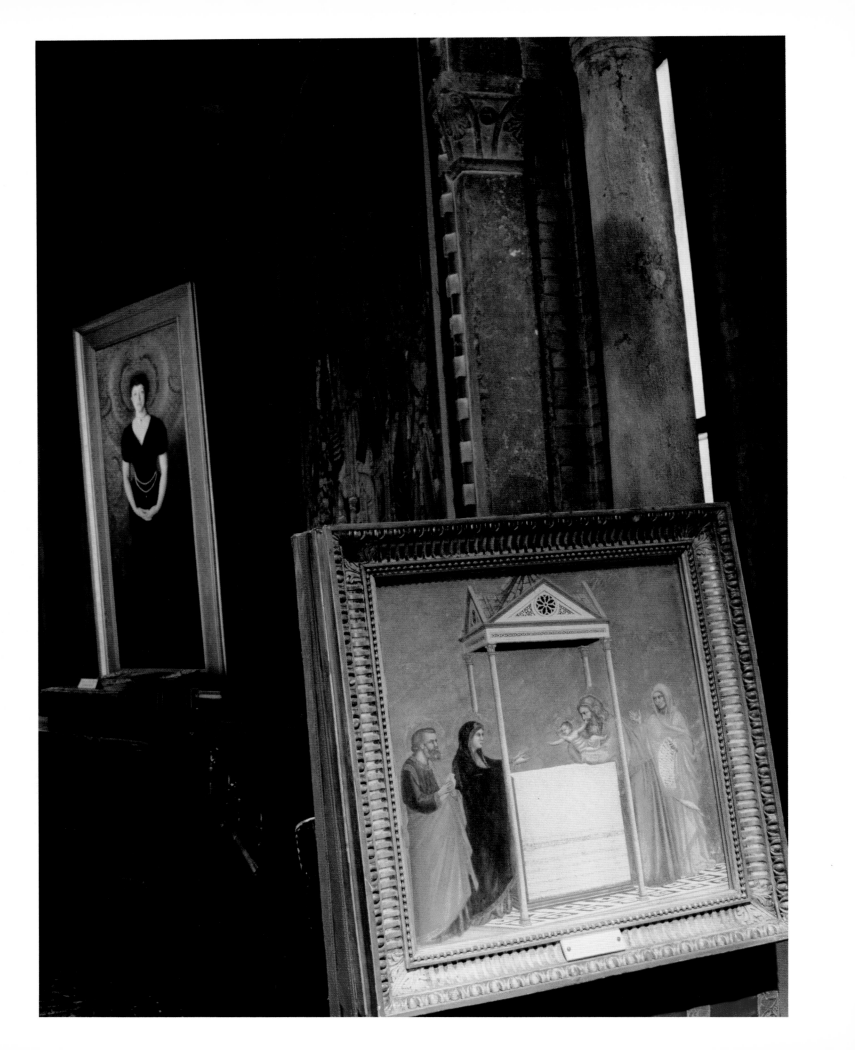

Stairway at Ralph Waldo Emerson's House, Concord, Massachusetts, 1985

Death Masks of Sacco and Vanzetti, Boston, Massachusetts, 1984

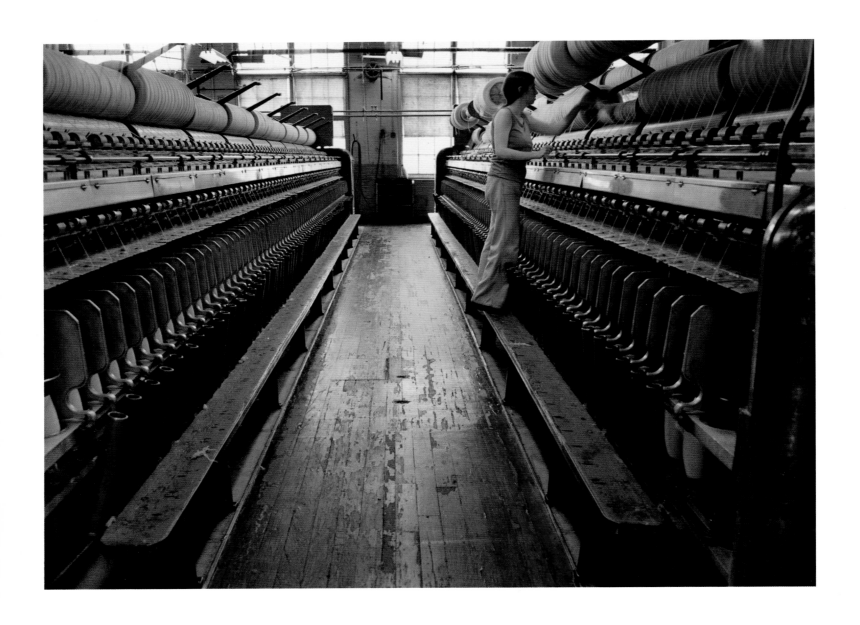

Factory Worker, Ware, Massachusetts, 1980

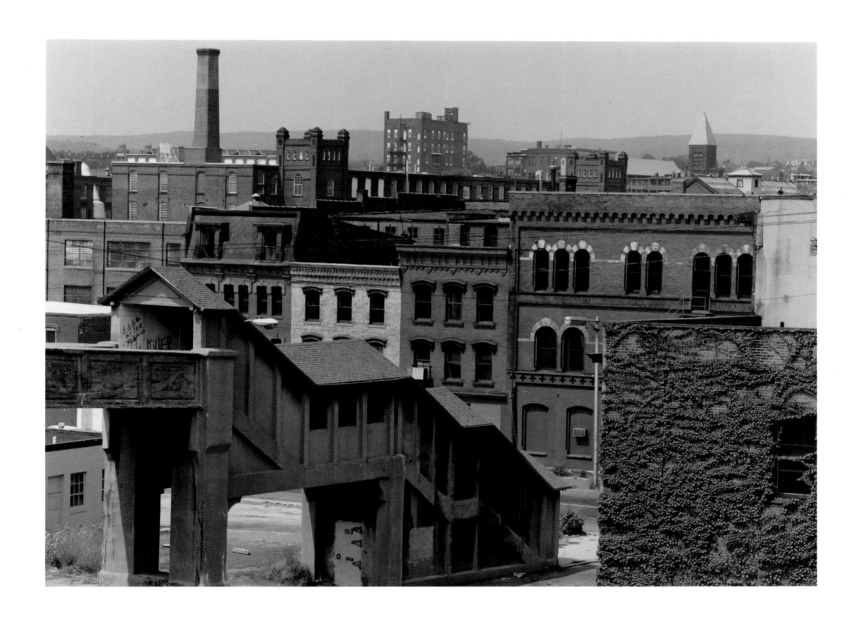

Holyoke, Massachusetts, 1980

Once, the Midwest's manufacturing power played a vital role in maintaining the United States' strong economy. But around 1980, the mines and steel industries began their decline, and the Midwest became known as the "Rust Bowl."

My photographs from these states show something of the pain this downturn brought. Each scene speaks of the disappearance of a way of life: An unemployed worker sits in a booth, hunched and slack, utterly detached. A decaying steel mill, soon to be bulldozed away, has a patina of rust. A lone woman stands before the darkened façade of a store. These are bleak pictures, of the dislocation and distress caused by the collapse of a region.

Morning, Monessen, Pennsylvania, 1983

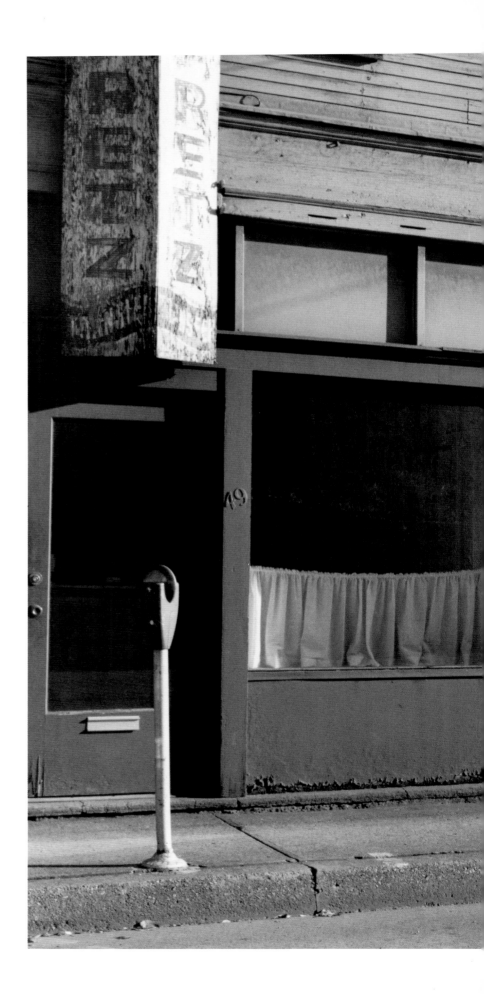

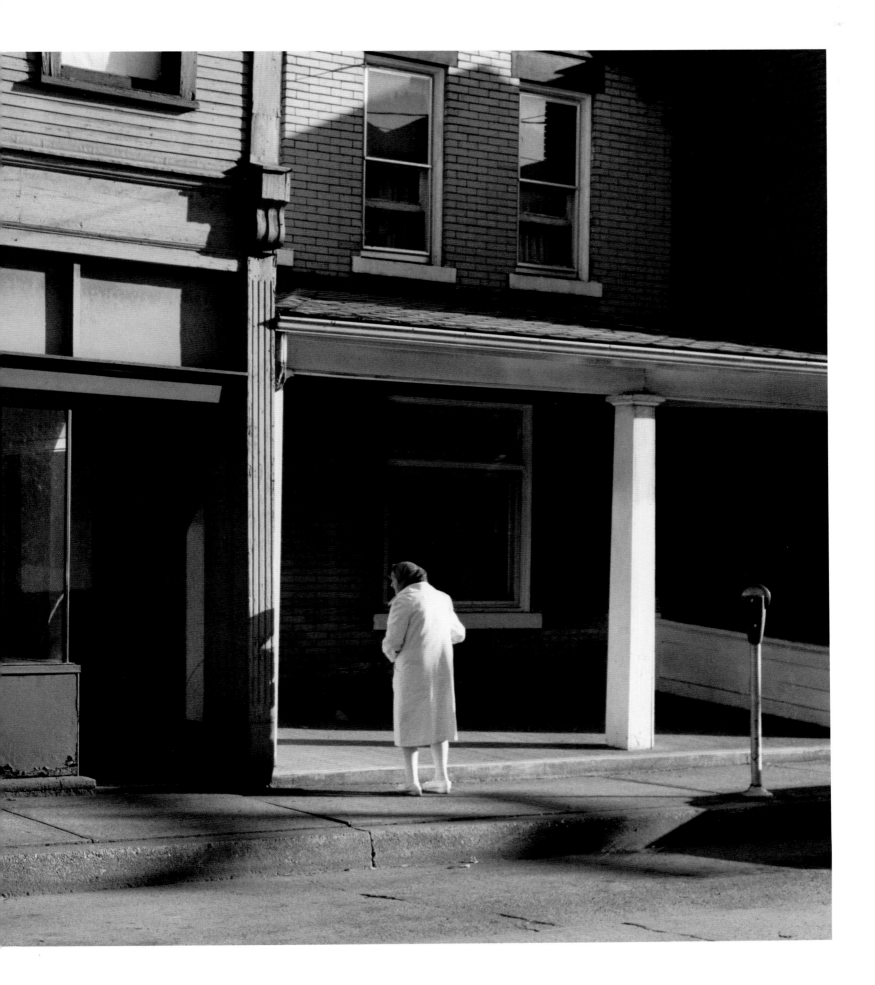

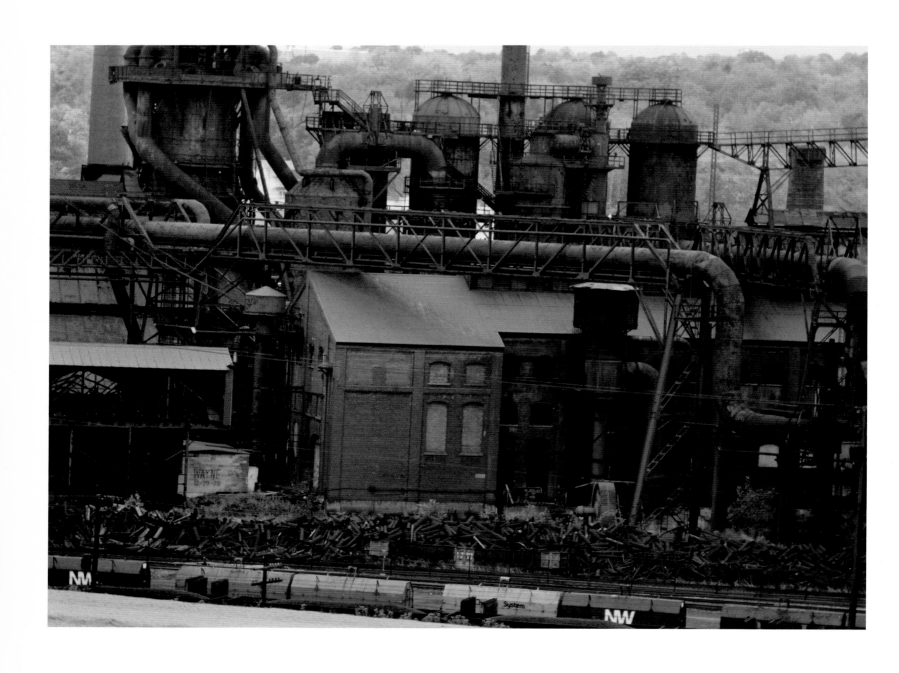

Above: *Steel Mill*, Youngstown, Ohio, 1982
Opposite: Man in Restaurant Booth, Weirton, West Virginia, 1982
Page 42: *Miner*, Ebbensburg, Pennsylvania, 1983
Page 43: *Miner's Wife*, Hibbing, Minnesota, 1983

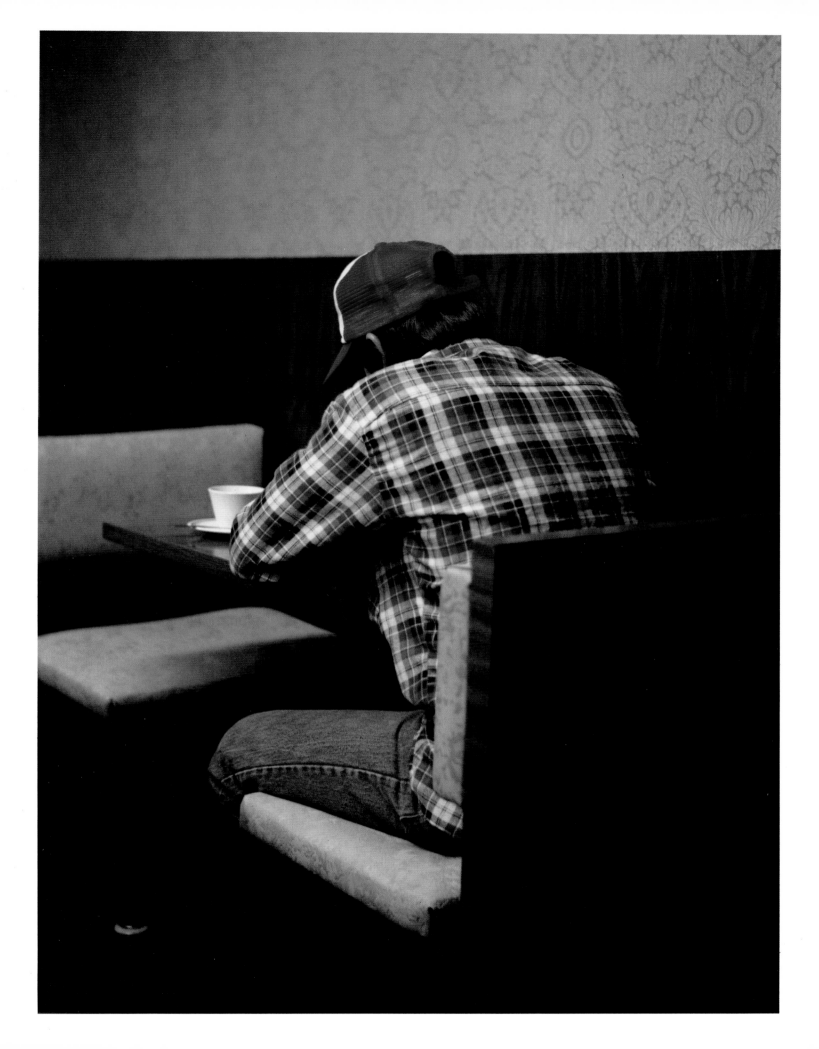

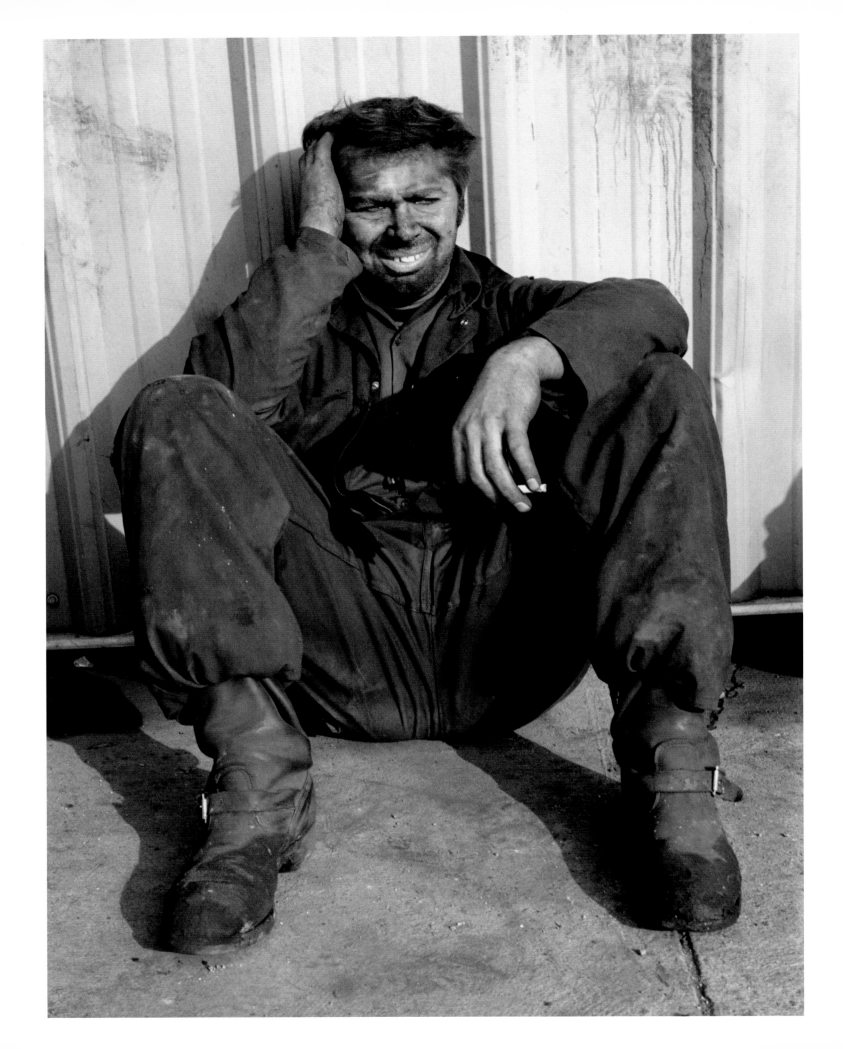

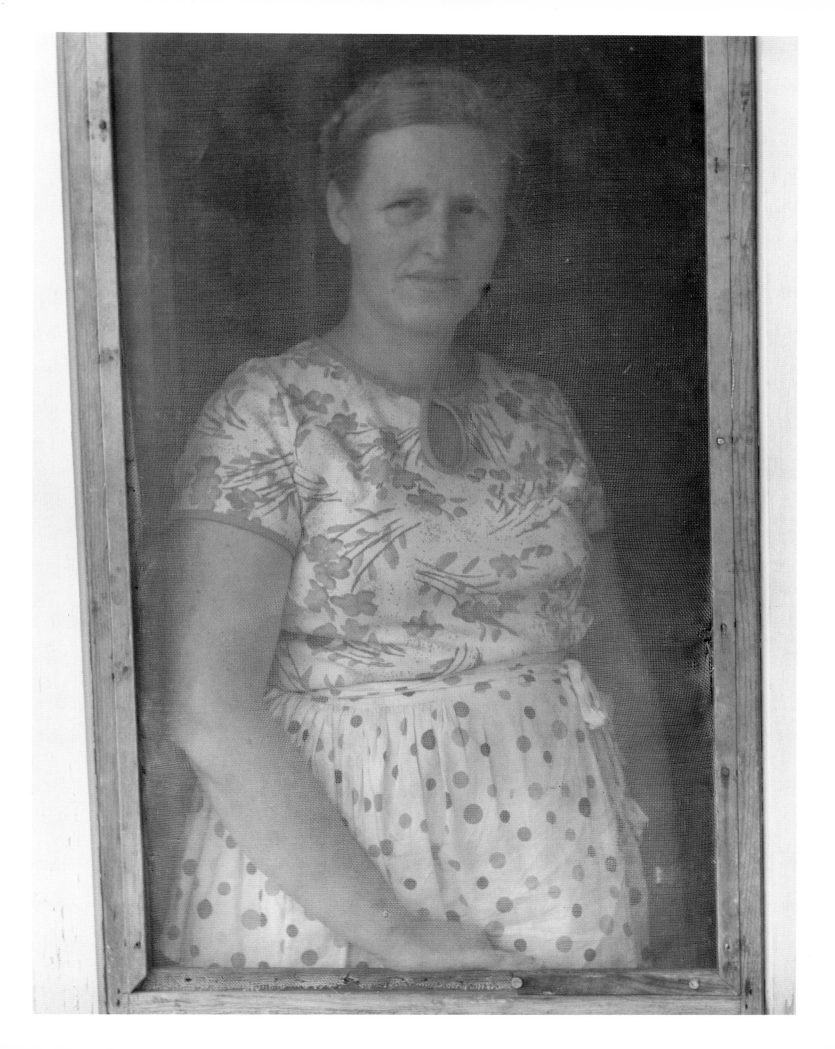

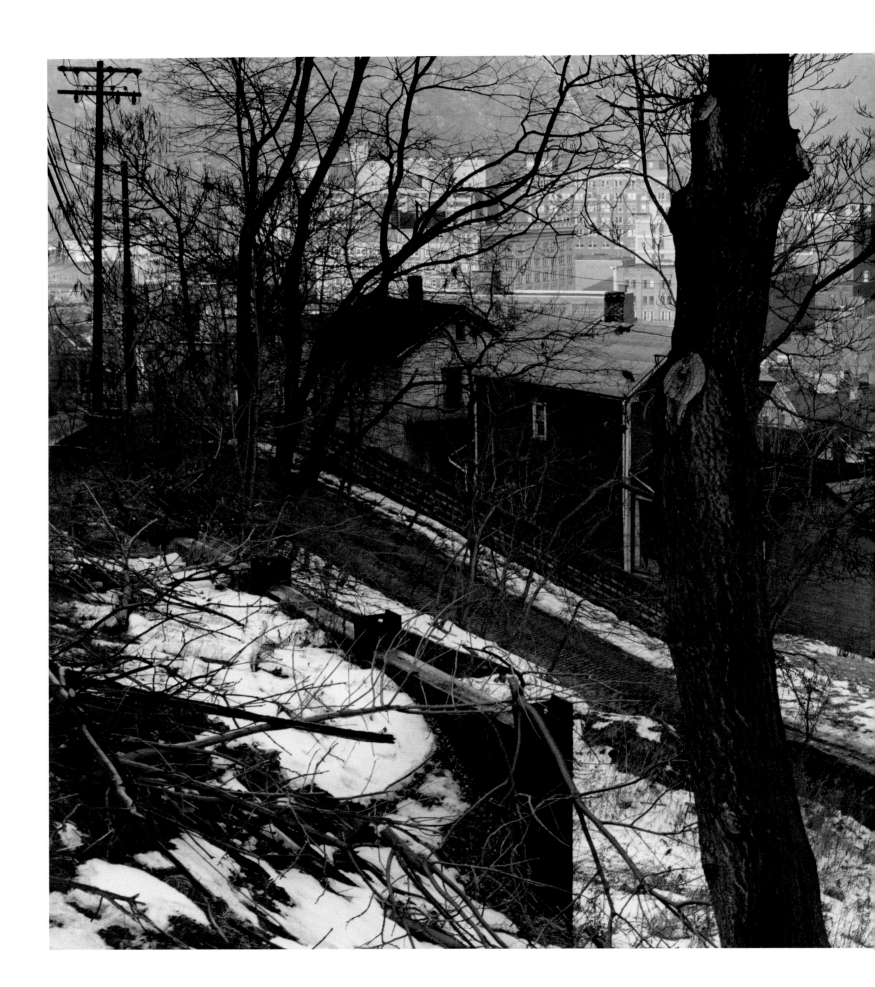

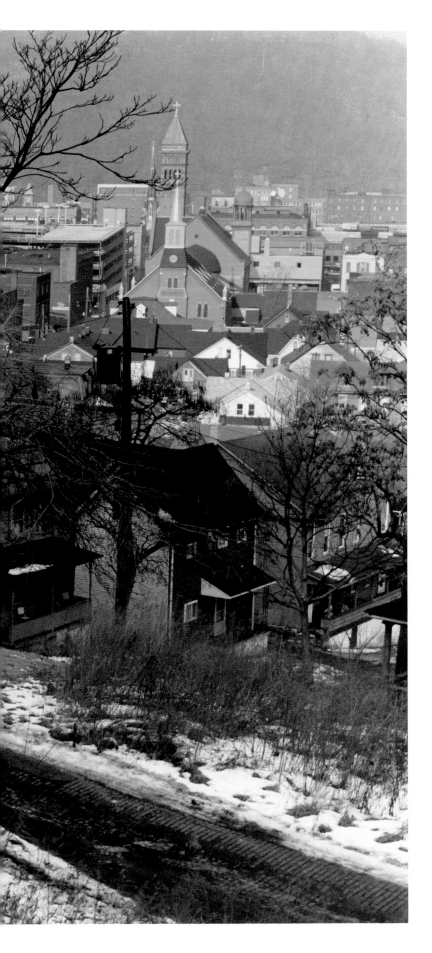

Johnstown, Pennsylvania, 1983

Emily Dickinson lived her whole
life in Amherst, Massachusetts, which
is now my home also. I pass her house
regularly, and am reminded of the
visions in her poetry.

As imperceptibly as Grief
The Summer lapsed away—
Too imperceptible at last
To seem like Perfidy—
A Quietness distilled
As Twilight long begun,
Or Nature spending with herself
Sequestered Afternoon—
The Dusk drew earlier in—
The Morning foreign shone—
A courteous, yet harrowing Grace,
As Guest, that would be gone—
And thus, without a Wing
Or service of a Keel
Our Summer made her light escape
Into the Beautiful.

—EMILY DICKINSON

Fence, Dickinson Homestead, Amherst, Massachusetts, 1982

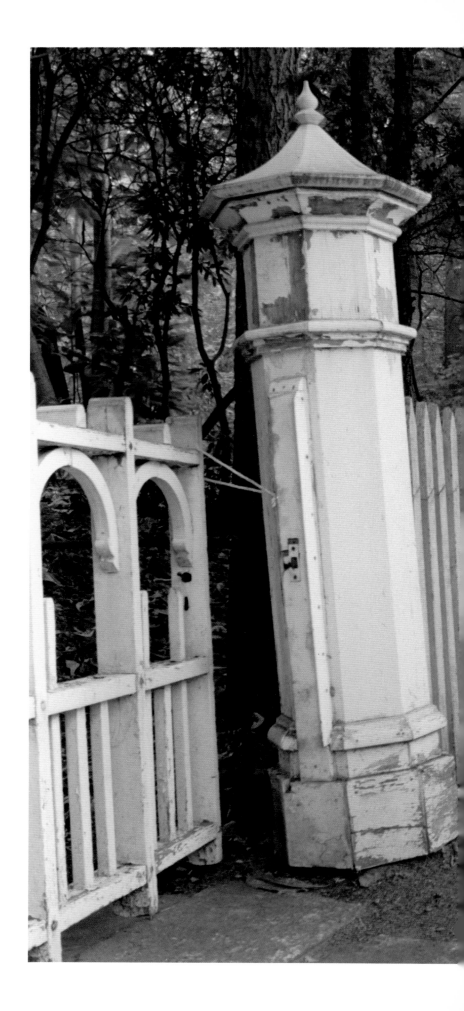

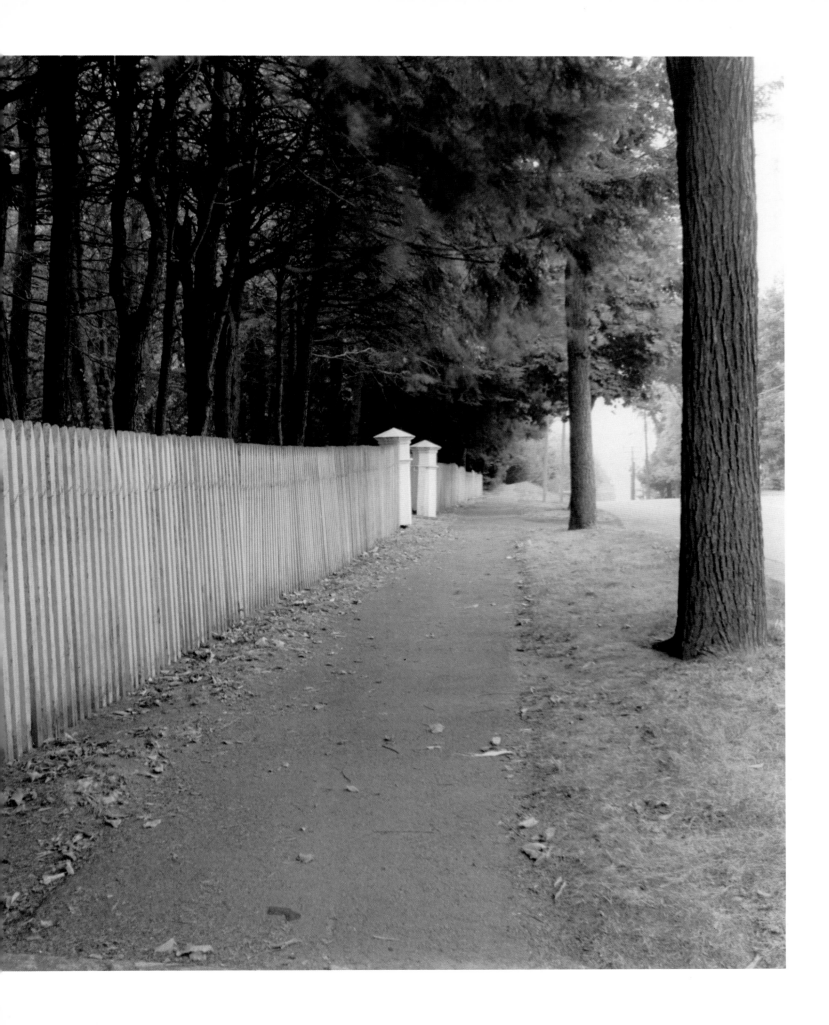

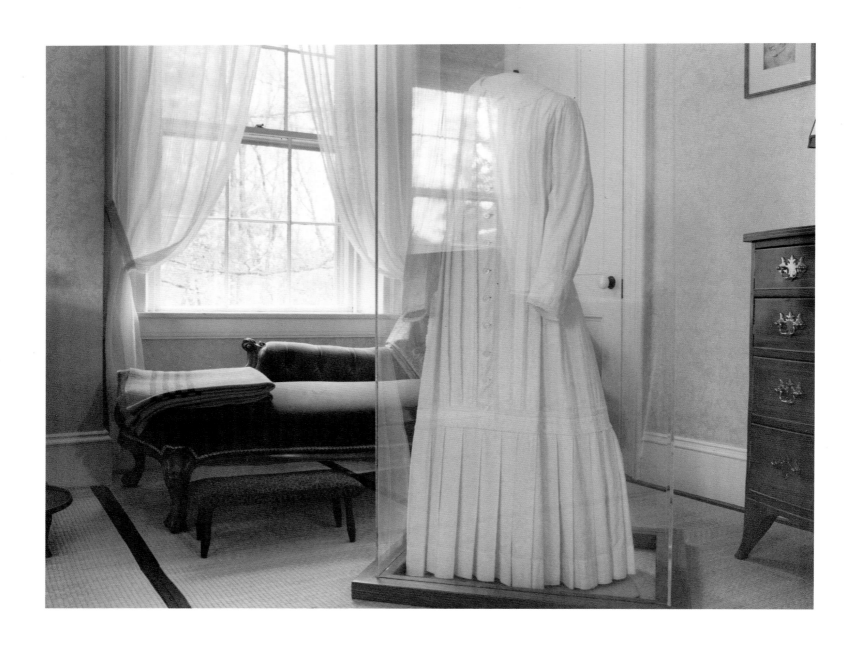

Above: Emily Dickinson's White Dress, Amherst, Massachusetts, 1989
Opposite: Emily Dickinson's Writing Desk, Amherst, Massachusetts, 1993

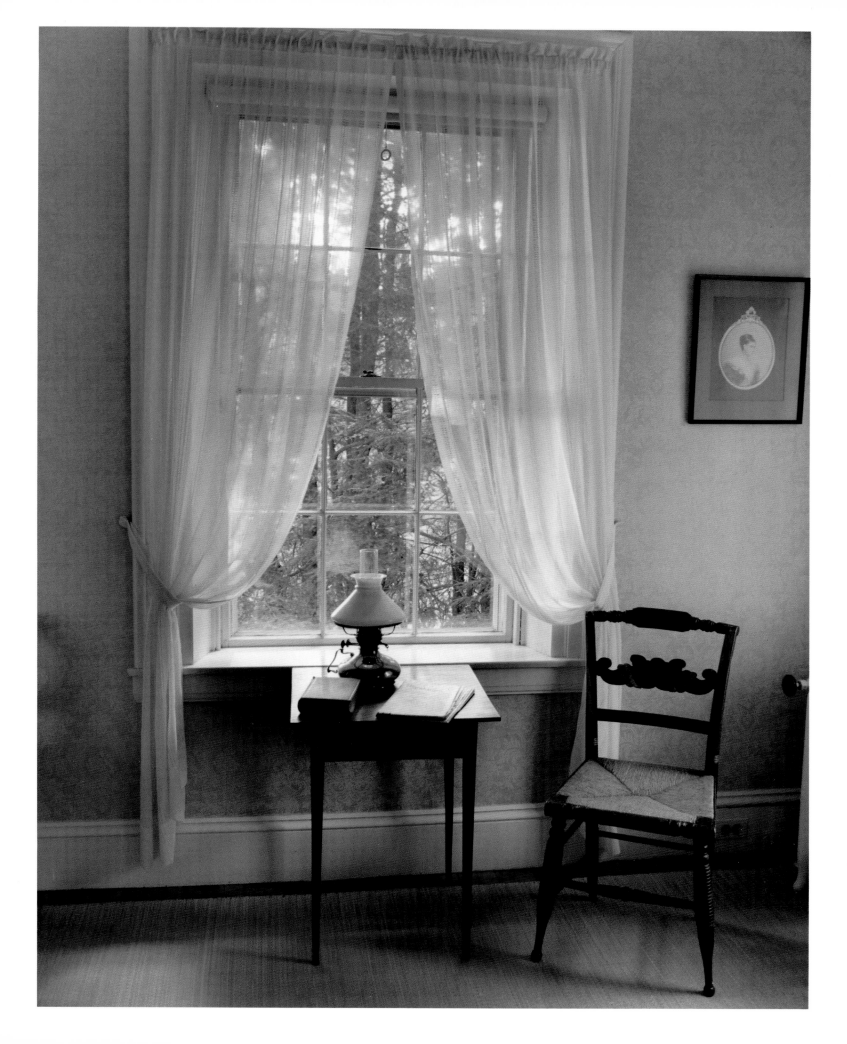

Mark Twain's Dining Room, Hartford, Connecticut, 1990

Harriet Beecher Stowe's Bedroom and Passage to Her Husband's Bedroom,
Hartford, Connecticut, 1990

In the spring, the fields suddenly come alive, and tractors begin to appear. The earth is turned and furrowed, the planting is done, and expectations for summer begin.

Having spent so much time among academics, I have a romantic vision of farming, and a deep reverence for those who do this work. There is such mystery in the knowledge of the seasons and their rhythms, how much to seed and when, watering, weeding, harvesting: this is *production*, in its most basic and satisfying form. It seems to me a wonderful secret, private and primordial.

Farming transforms the landscape with colors and shapes, beautiful and dramatic: it is, I think, permissible to romanticize this vision.

Atkins Apple Orchard, Amherst, Massachusetts, 1979

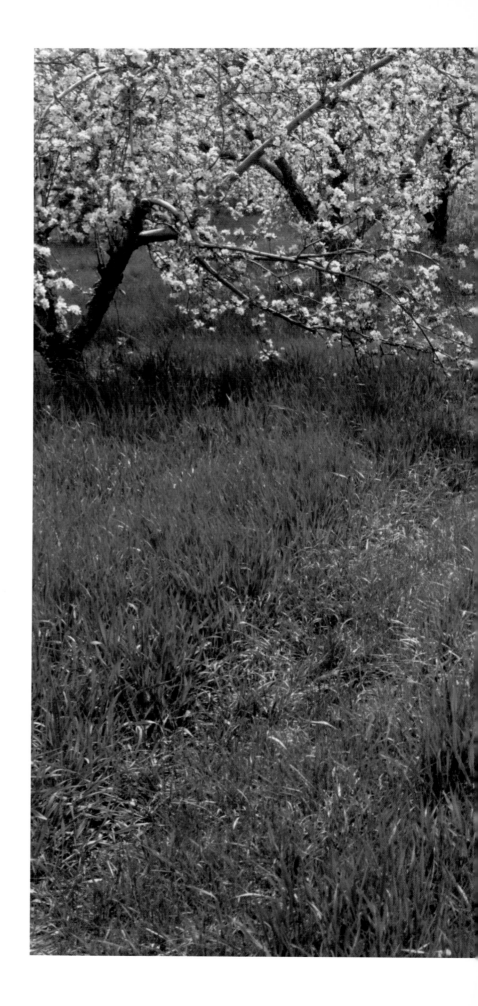

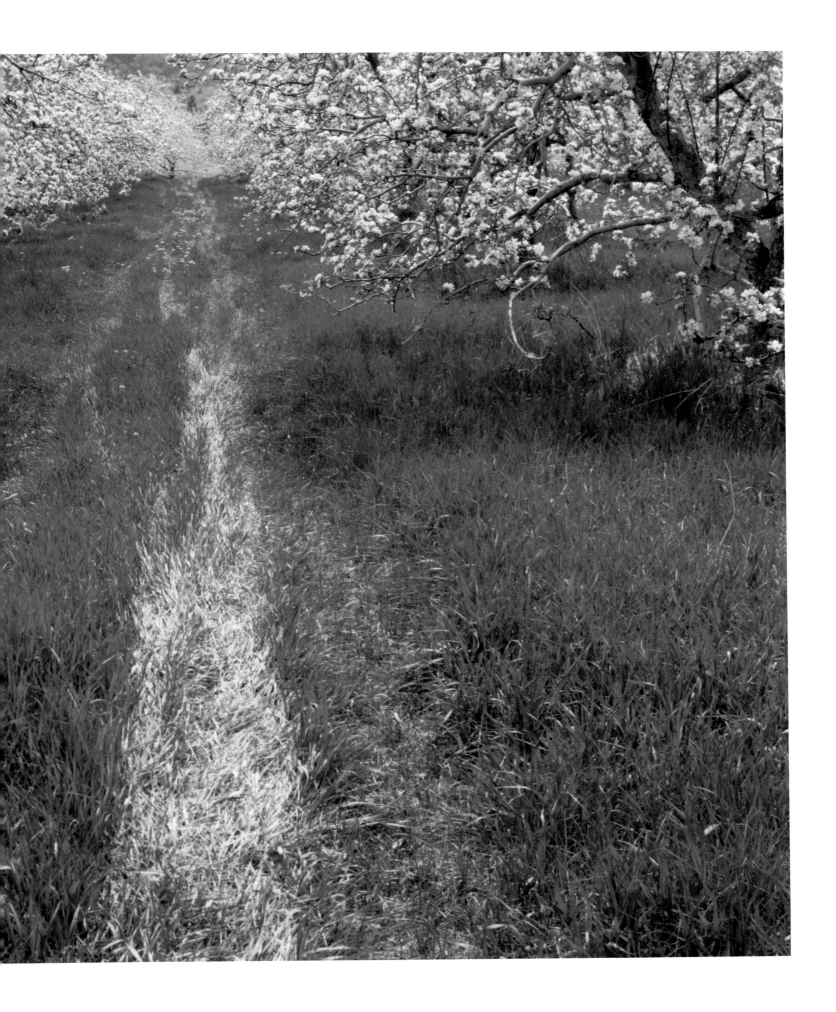

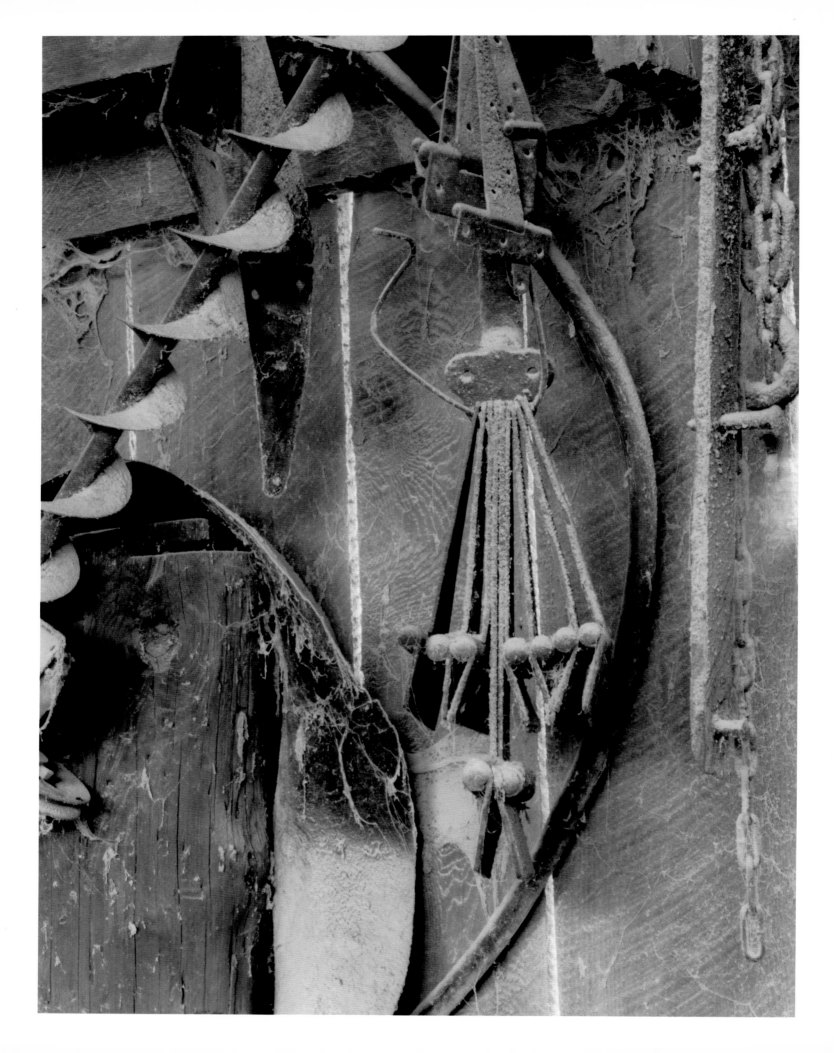

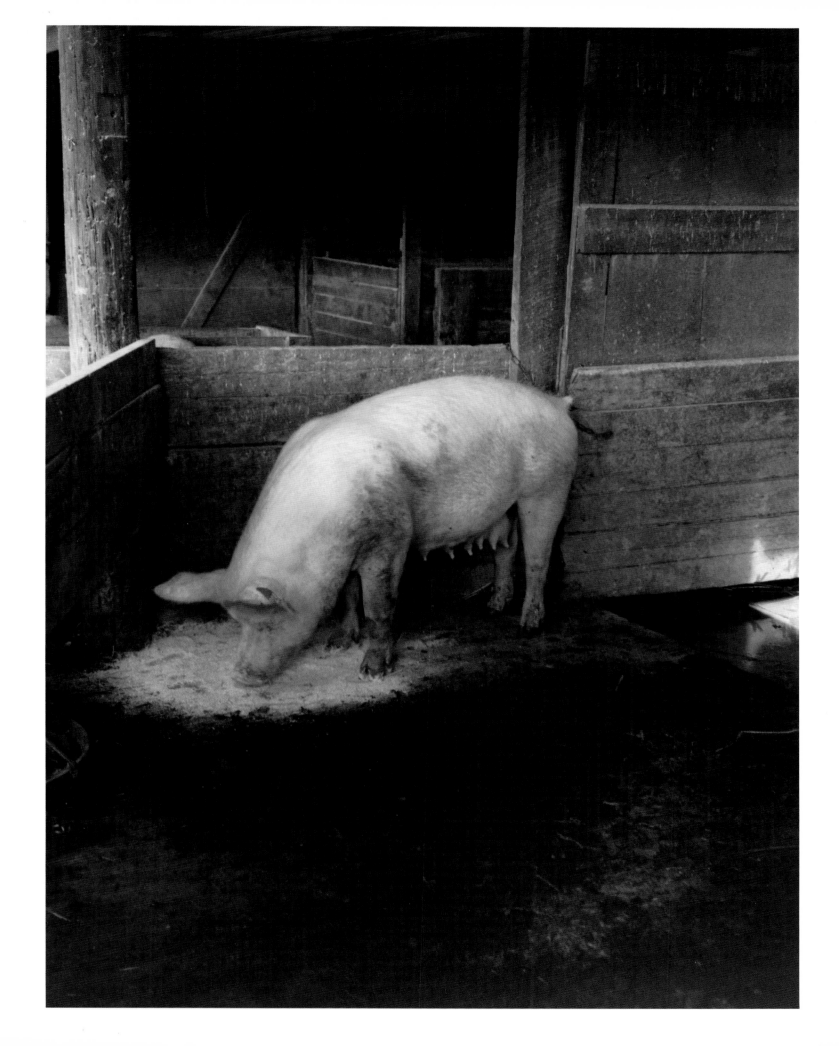

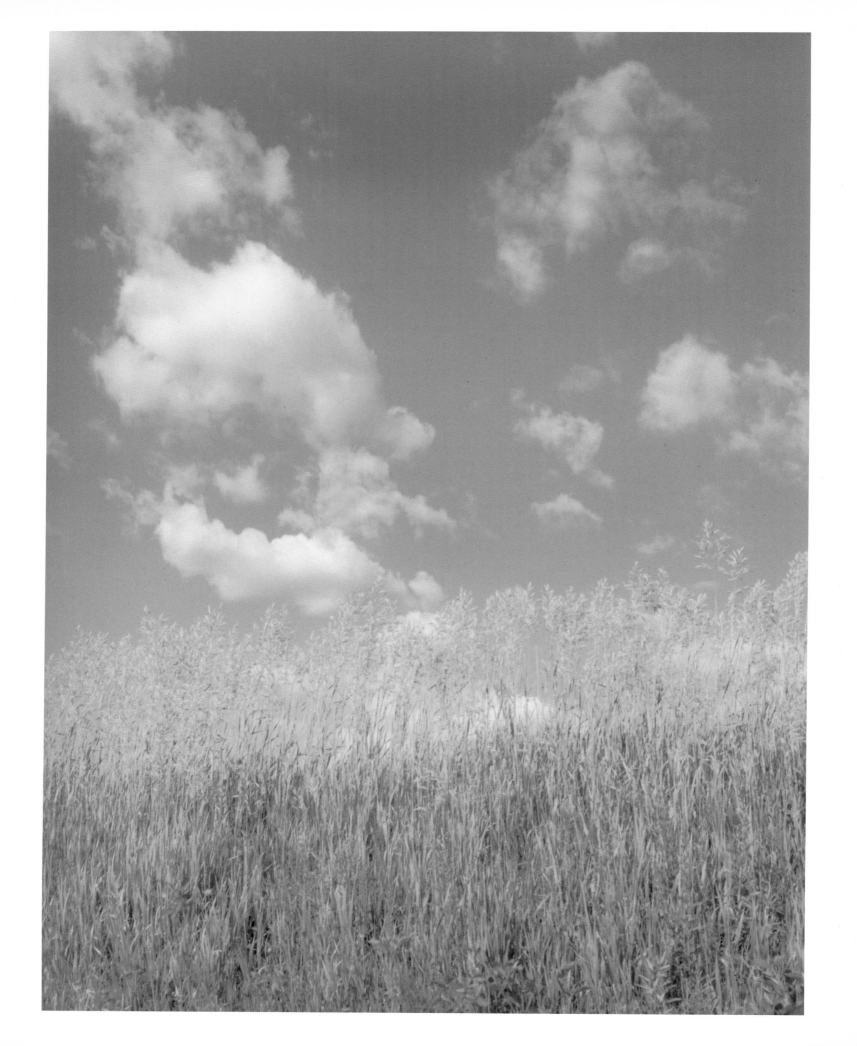

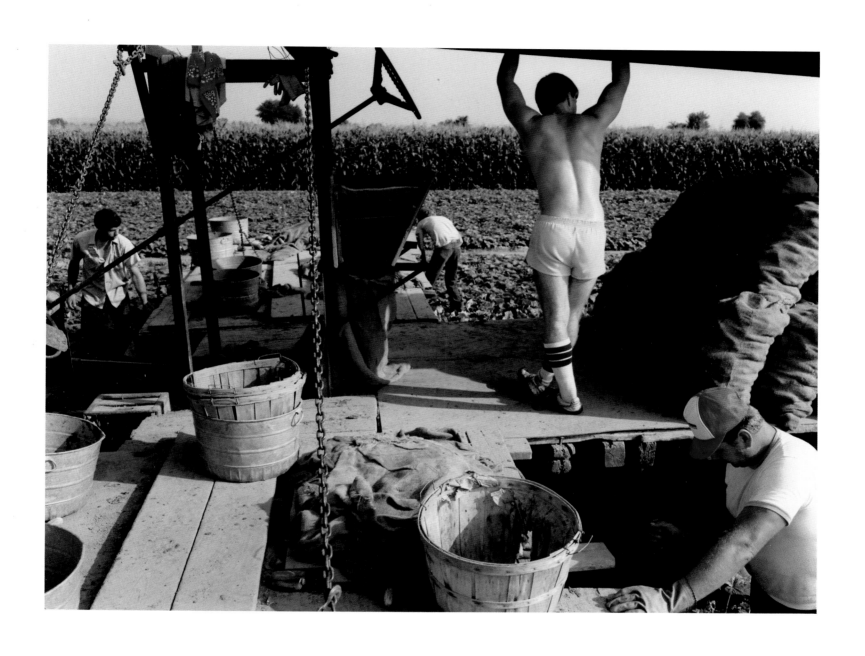

Page 54: *Barn*, Hadley, Massachusetts, 1985
Page 55: *Pig*, Hadley, Massachusetts, 1984
Opposite: Grass, Sky, Hadley, Massachusetts, 1985
Above: Picking Cucumbers, Hadley, Massachusetts, 1985

Are you free as you are? Are you in any degree bound by your appetites, your passions, your self-will? Are you in bondage to the opinion of your neighbor, to the customs and notions of society, however harmful or absurd? These do not trammel the true Shaker.

—ELDRESS ANNA WHITE

The work of the Shakers—their crafts and their architecture—is a living testament to the Shaker credo of discipline and absolute devotion. They had an intense dedication to the ideal of total purity, in both body and spirit—their lives were spent fighting their own frailties and the pressures and temptations of the secular world.

To me, their work is full of the tension that must arise from such extreme discipline. There is a phenomenal control in the Shaker crafts: an equilibrium that is precarious, and yet very taut. In my pictures, I have tried to reflect the tension of their world.

Shaker Village, Hancock, Massachusetts, 1985

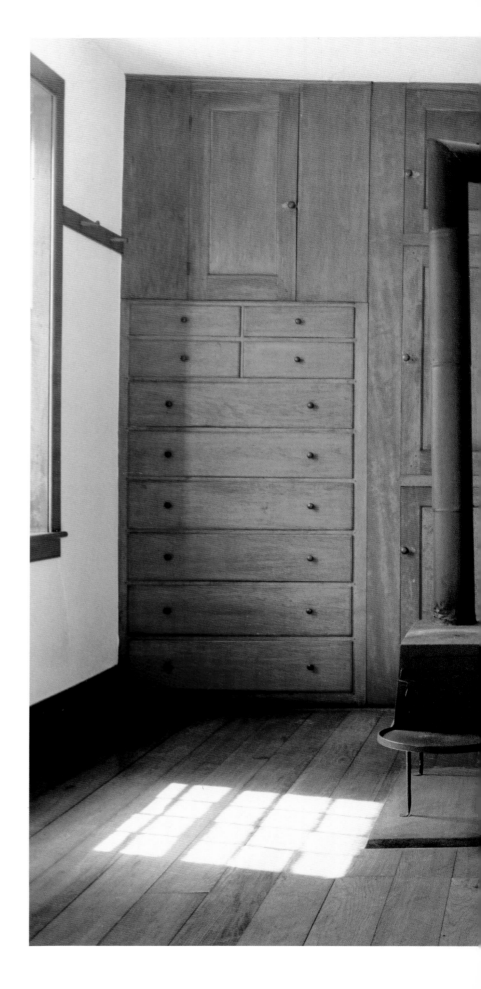

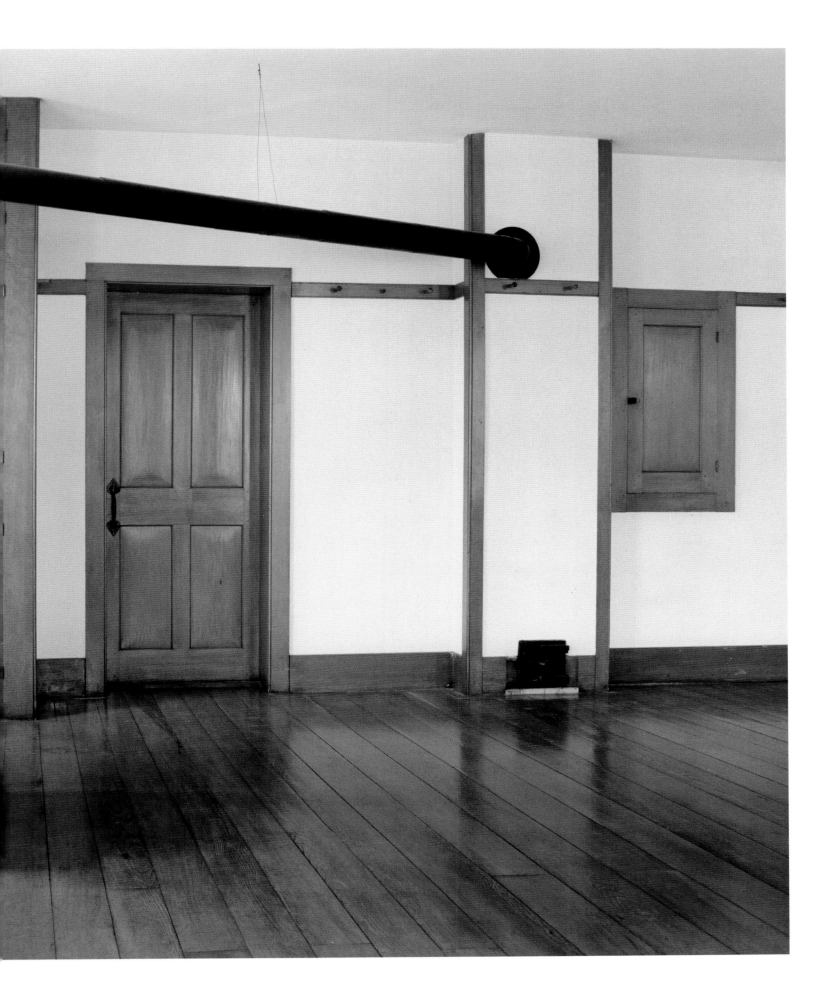

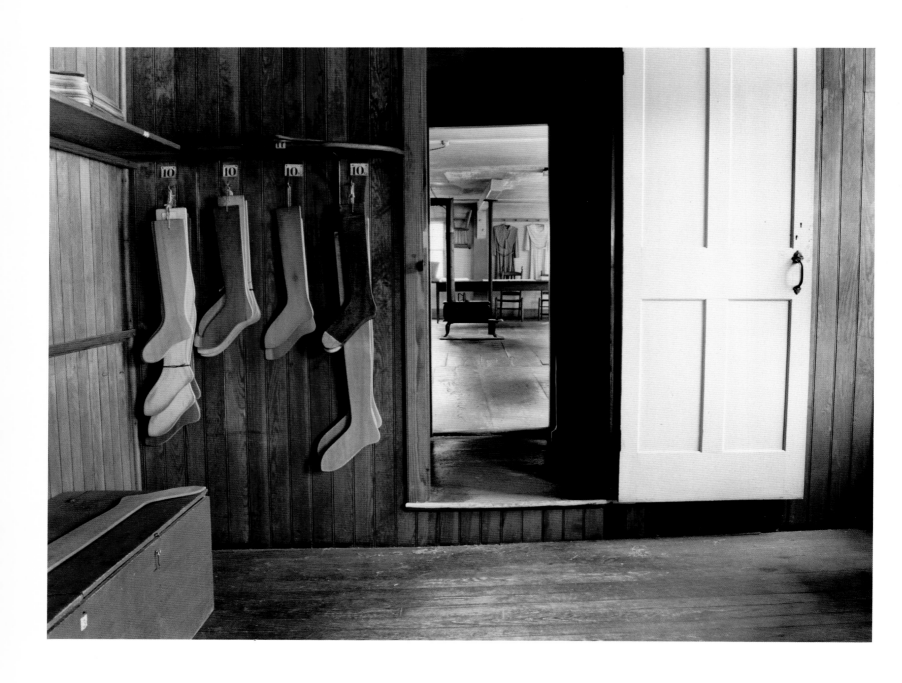

Above: Shaker Laundry Room, Canterbury, New Hampshire, 1986
Opposite: Shaker Stove, Hancock, Massachusetts, 1985

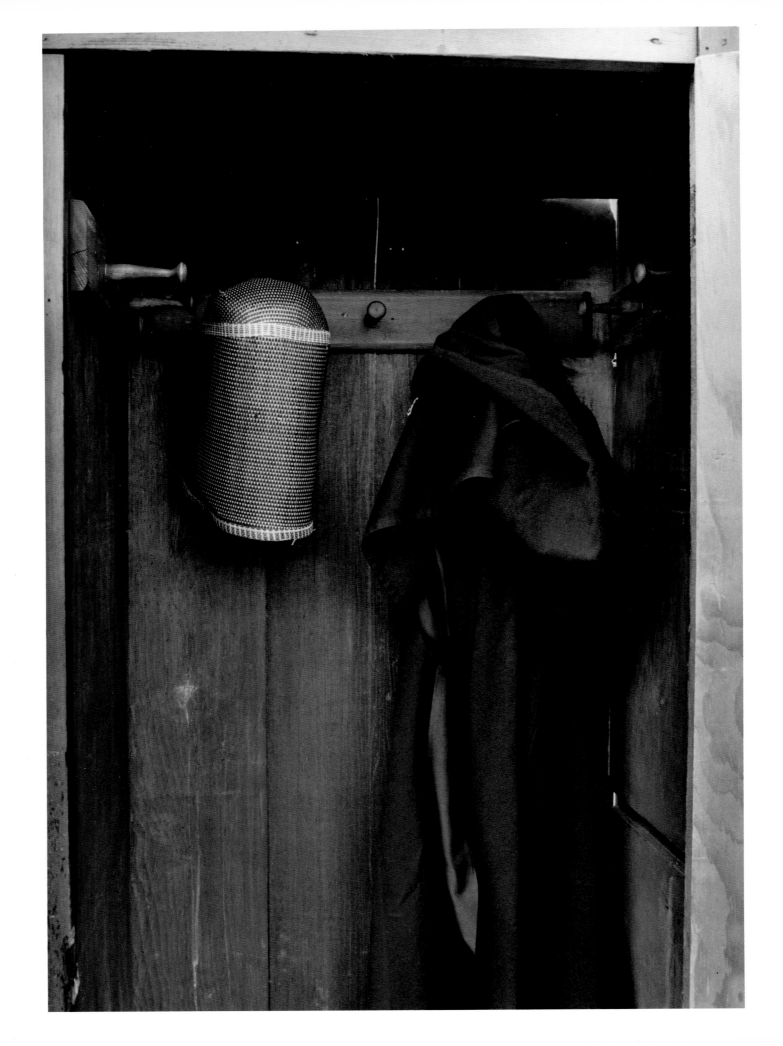

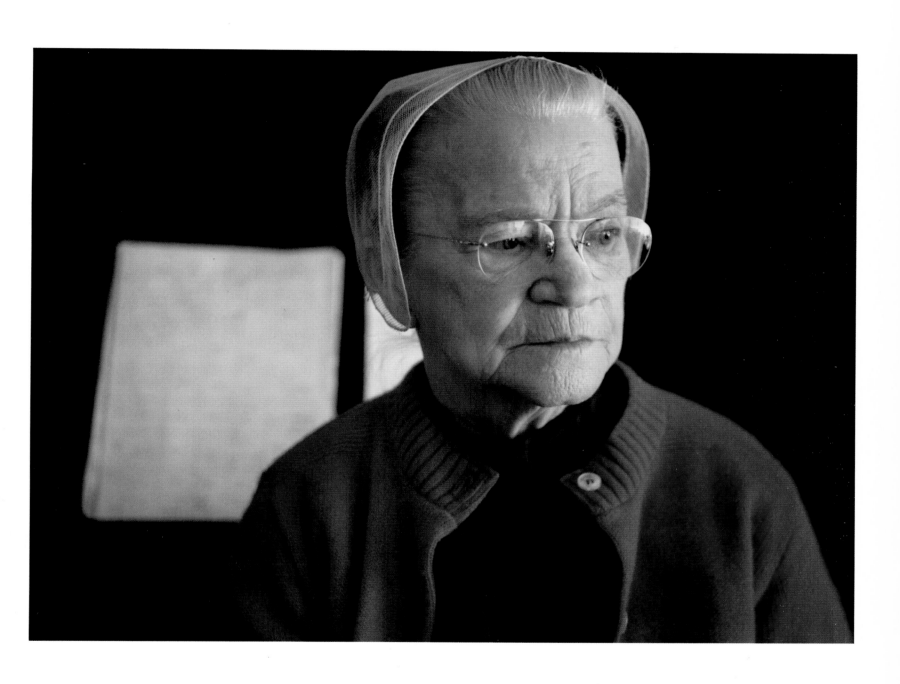

Opposite: Shaker Cloak, 1985-86
Above: Sister Gertrude Soule, Canterbury, New Hampshire, 1986

Starting in 1953 I photographed and made films of the Chippewa tribe at Red Lake, Minnesota, and later of the Blackfeet in Browning, Montana. My friend and colleague Allen Downs and I documented these groups in an attempt to connect with a culture that was so radically different in worldview from our own. We listened and observed, and tried to record the inner voices and forces of the Native American life. The films *A Tree is Dead* and *The Old Men* are some of the results of our exploration.

In the still photographs, I attempted to fuse a sense of the Indian life-force within a single, minimal pictorial image. This fusion is more complex in photography than in filmmaking; as a medium, film provides for many more juxtapositions and allows you information from the past, present, and future. In the photographs, all of the stubbornness, dignity, and indignation of a spirit must be captured and synthesized in one immediate visual experience.

I wanted the pictures of elders to show their deep awareness of tradition, their memory of the "old ways" of their people. The folds of clothing, the brim of a hat, the weathered lines of a face all work together to reveal something of the psyche of a culture.

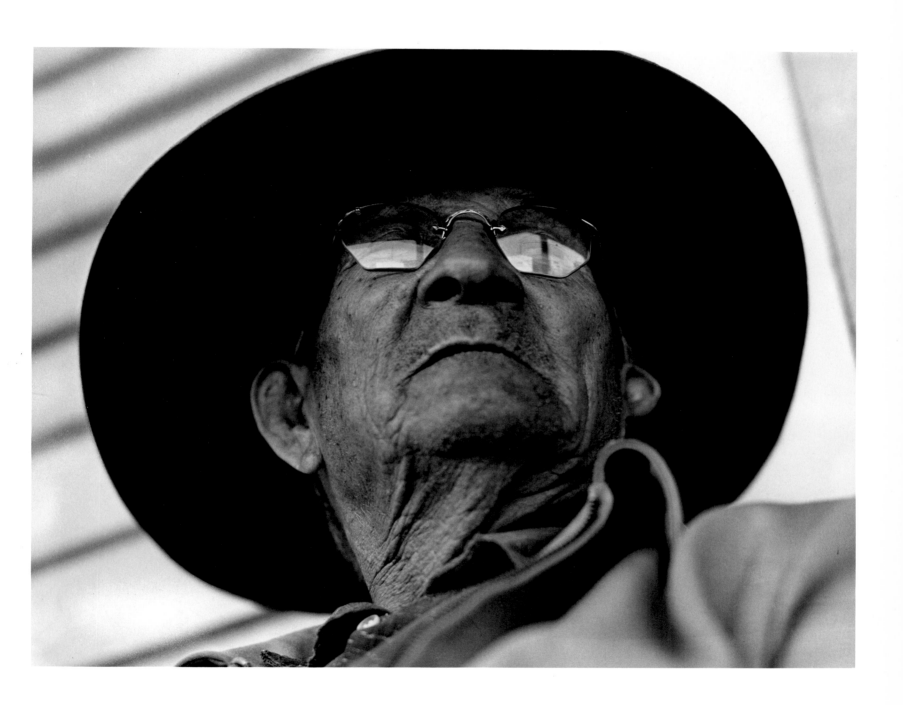

Native American, Montana, 1962

65

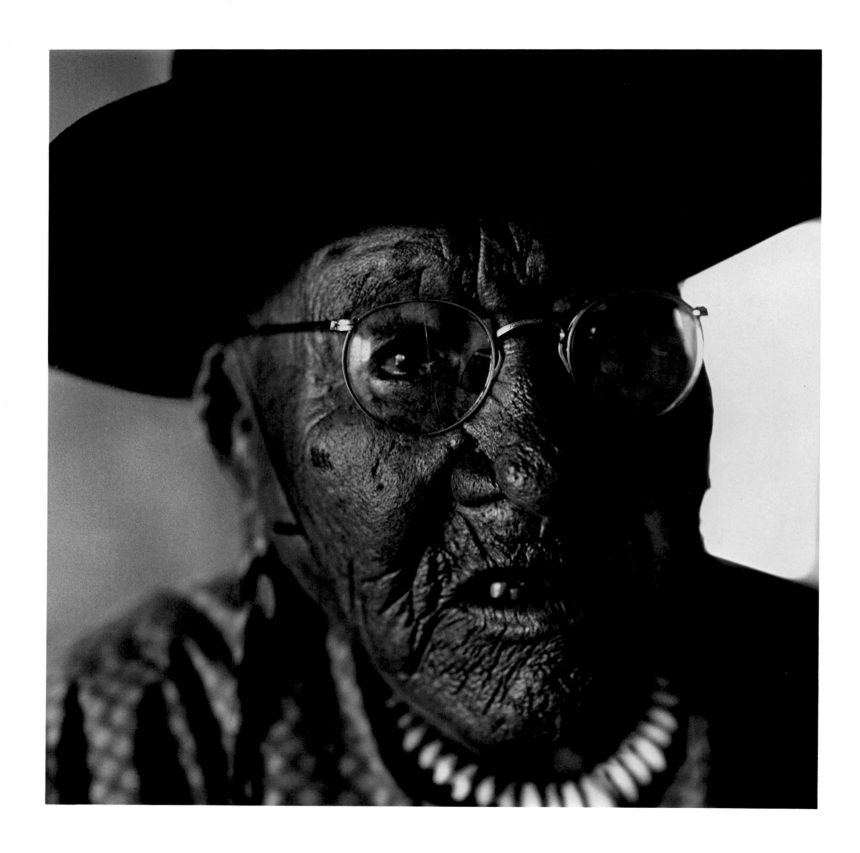

Chief Running Bear, Browning, Montana, 1963

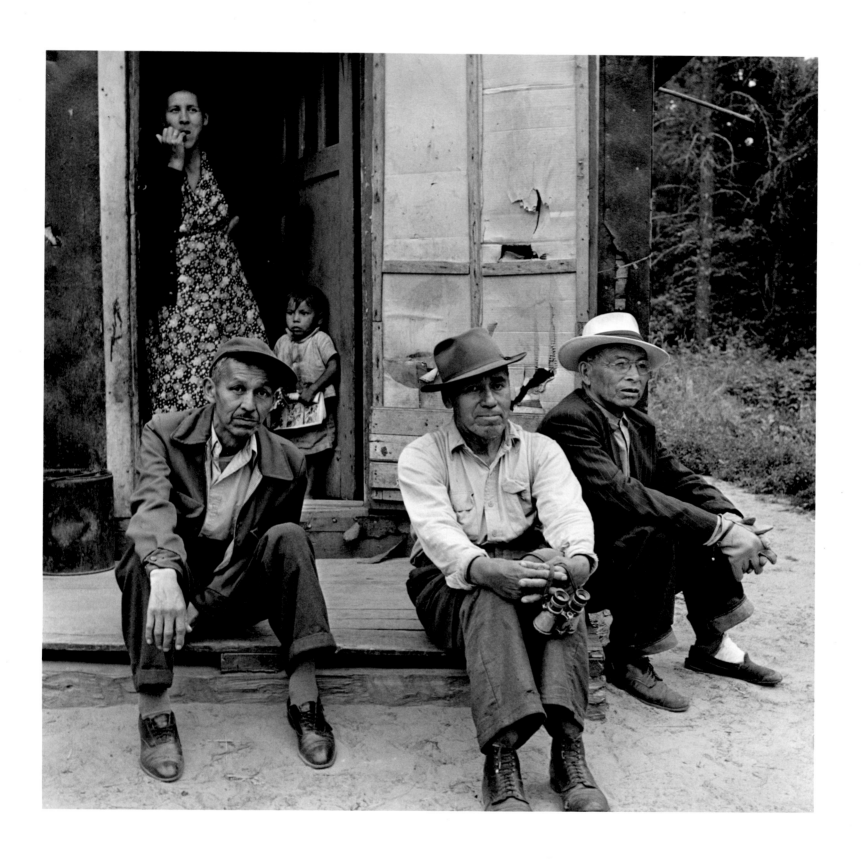

Family, Red Lake, Minnesota, 1954

Horse Skeleton and Weed, Browning, Montana, 1963

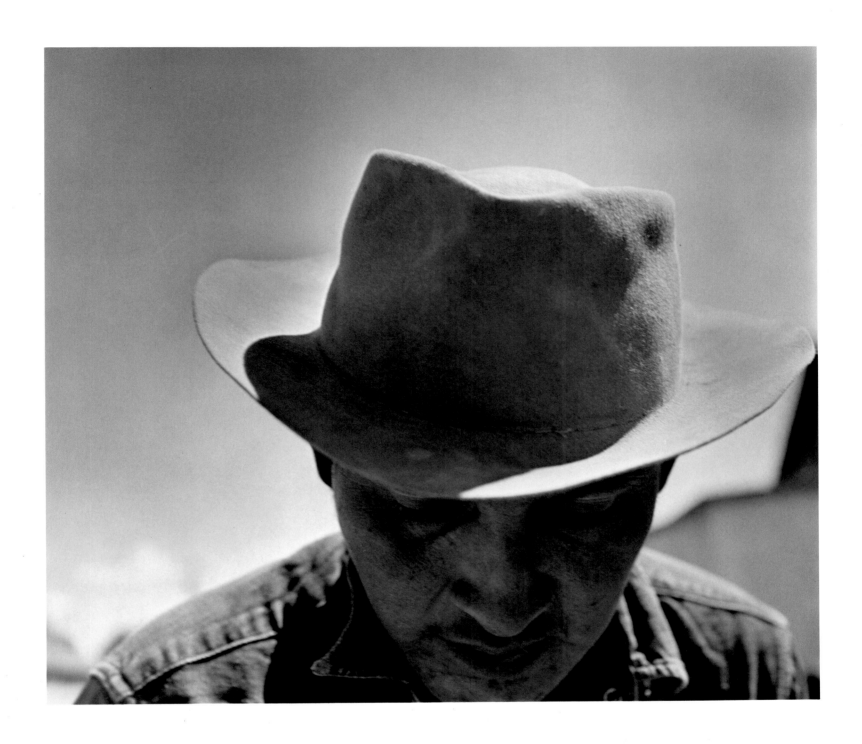

Man and Hat, Browning, Montana, 1963

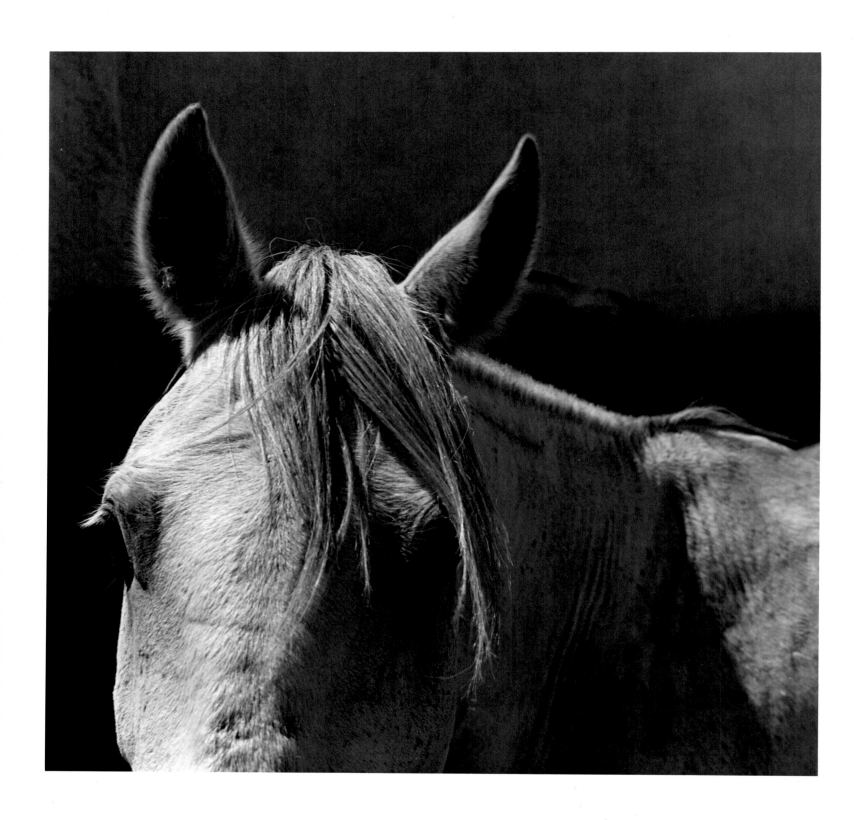

Horse's Head, Browning, Montana, 1964

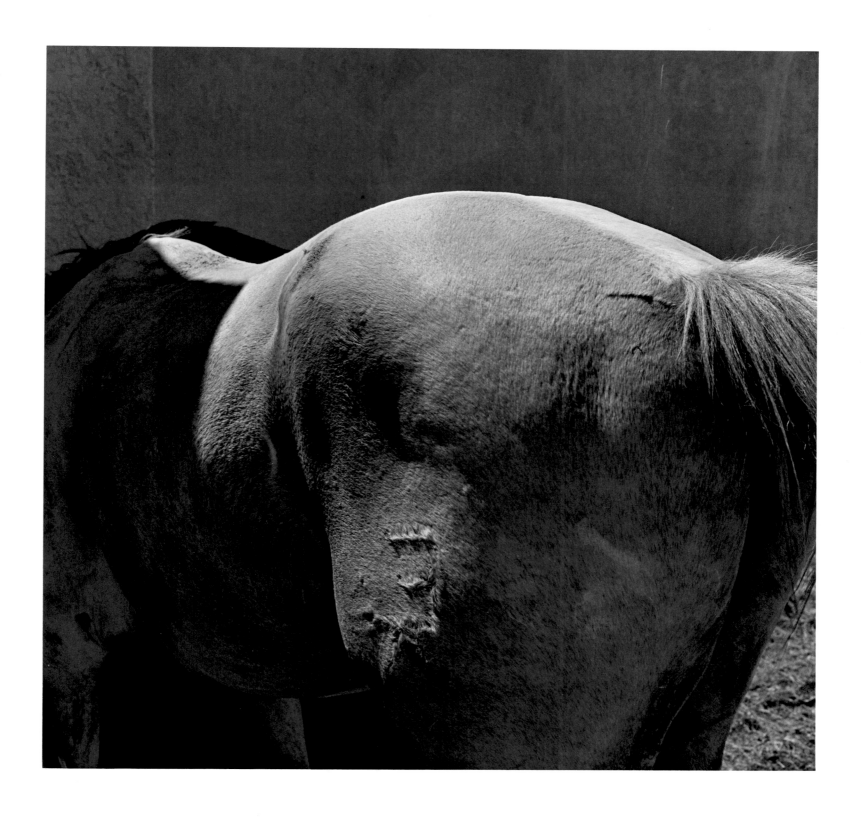

Horse's Rump, Browning, Montana, 1964

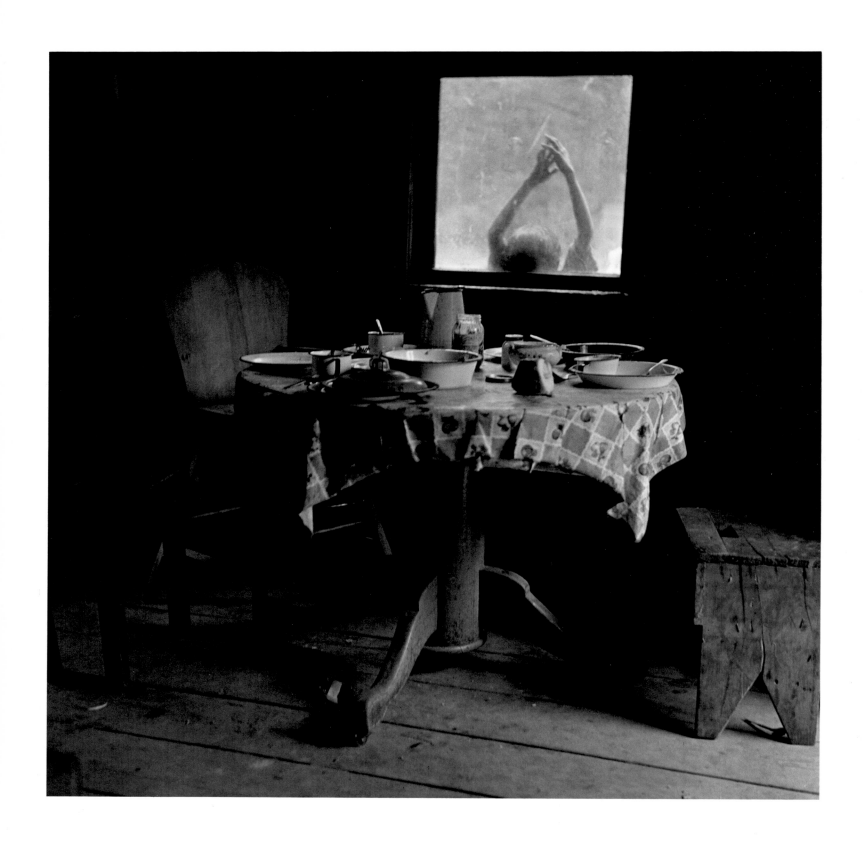

Interior, Red Lake, Minnesota, 1953

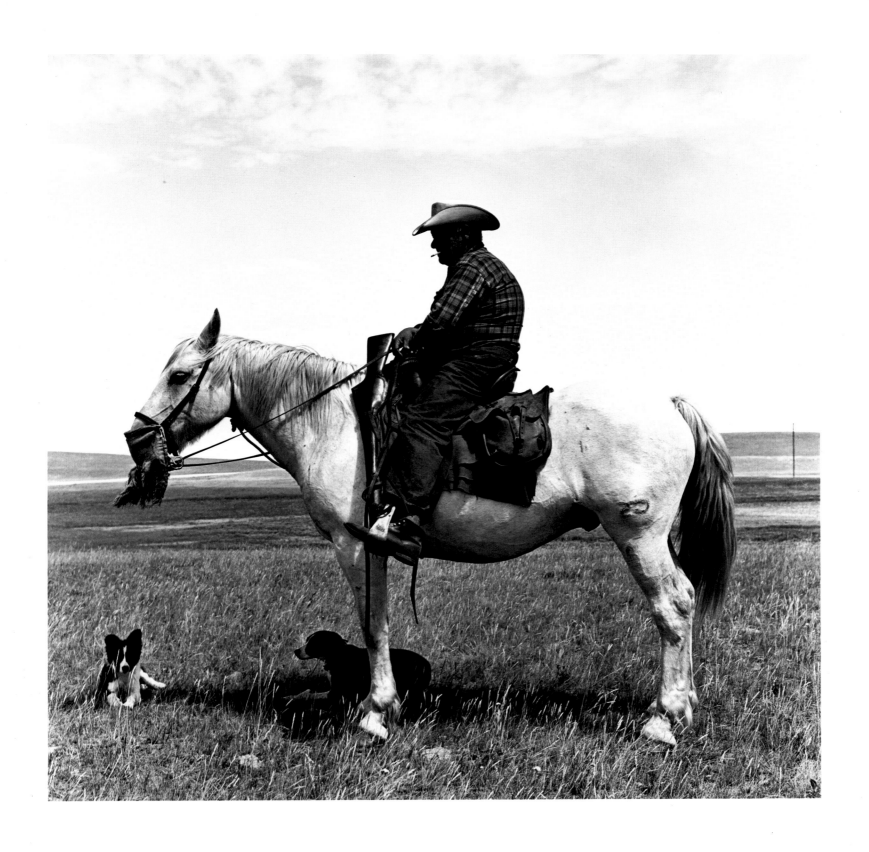

Browning, Montana, 1962

Our culture has a notion that beauty peaks and then fades, that it is not perpetual. A notion that the natural order has an unstoppable flow, which favors one moment more than another. These ideas are heavily imposed on us, and it can be hard to break away from them.

These three pictures are a sparse tribute to ongoing change and continuing beauty.

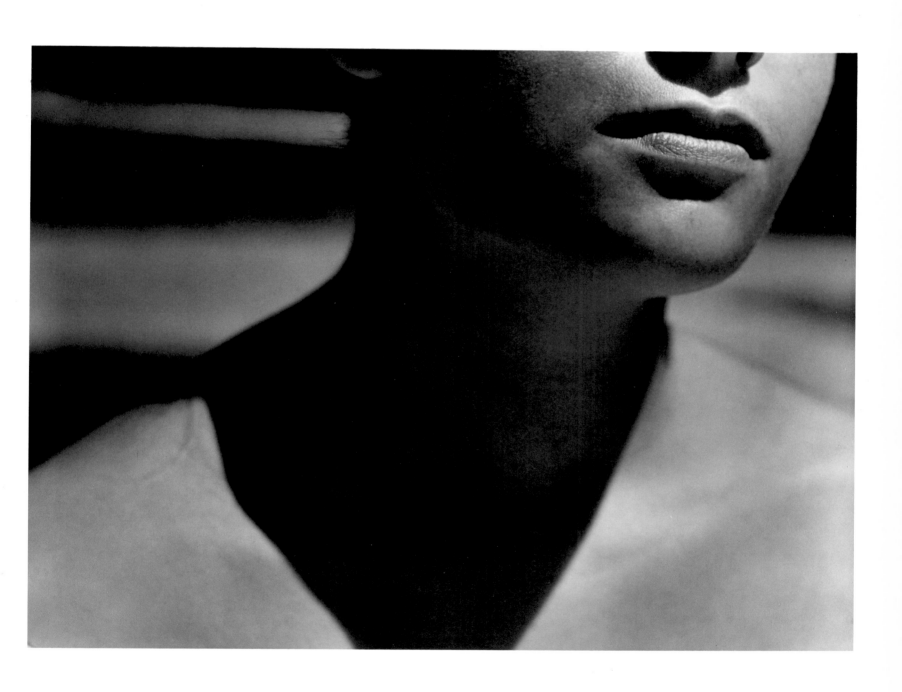

Neck, Lips, 1960

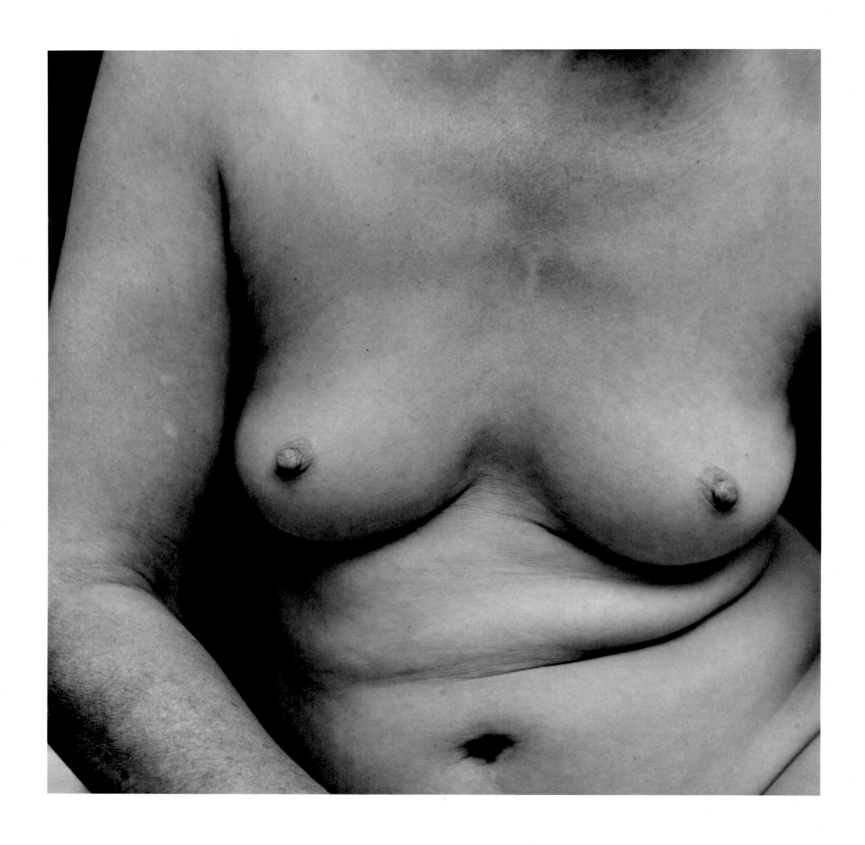

Woman, 1962

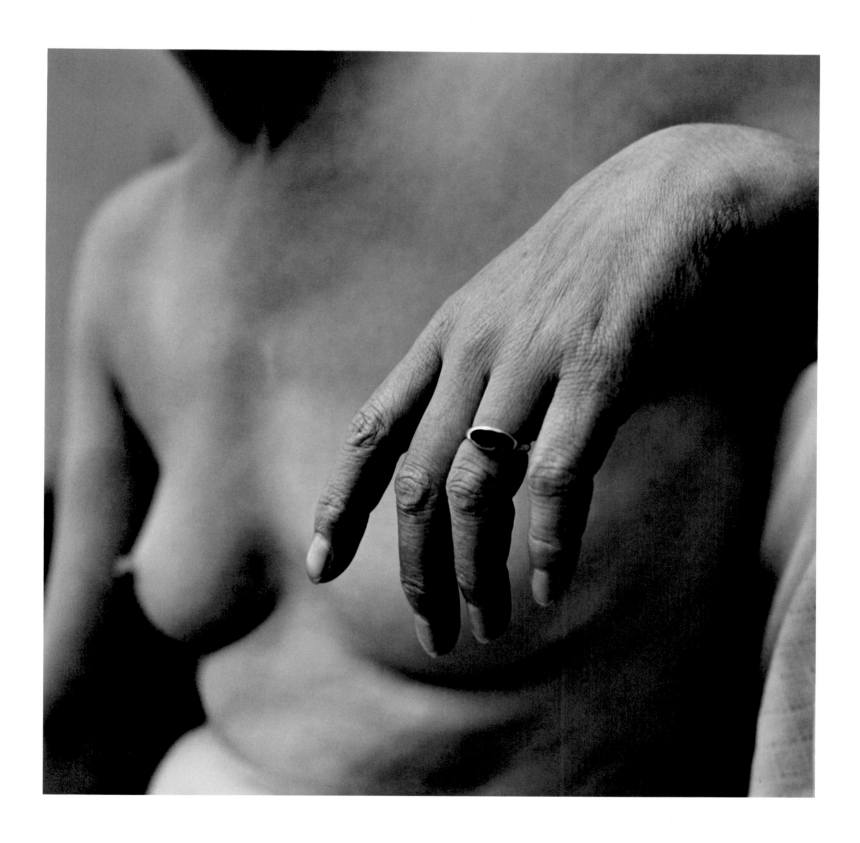

Woman, Hand, 1962

After death, what is left to express the force of life? Are we connected to the world for this short time only to be suddenly so irrevocably removed? In the body that remains, is there some residue of the spirit, of the soul?

Medical students in their first-year anatomy class are usually given a cadaver and a lesson book, and for a semester they explore, dissecting and inspecting the formaldehyde-preserved body from the outside in. There are no spiritual guides for them. It is a scientific and very rational procedure. Death can be looked at in this way.

I believe that my portraits of cadavers are both pious and profane. They represent the past folded into the present. Every wrinkle, cut, and fixed gaze intermixes with the life of the viewer.

It is the sense of mortality that defines us all.

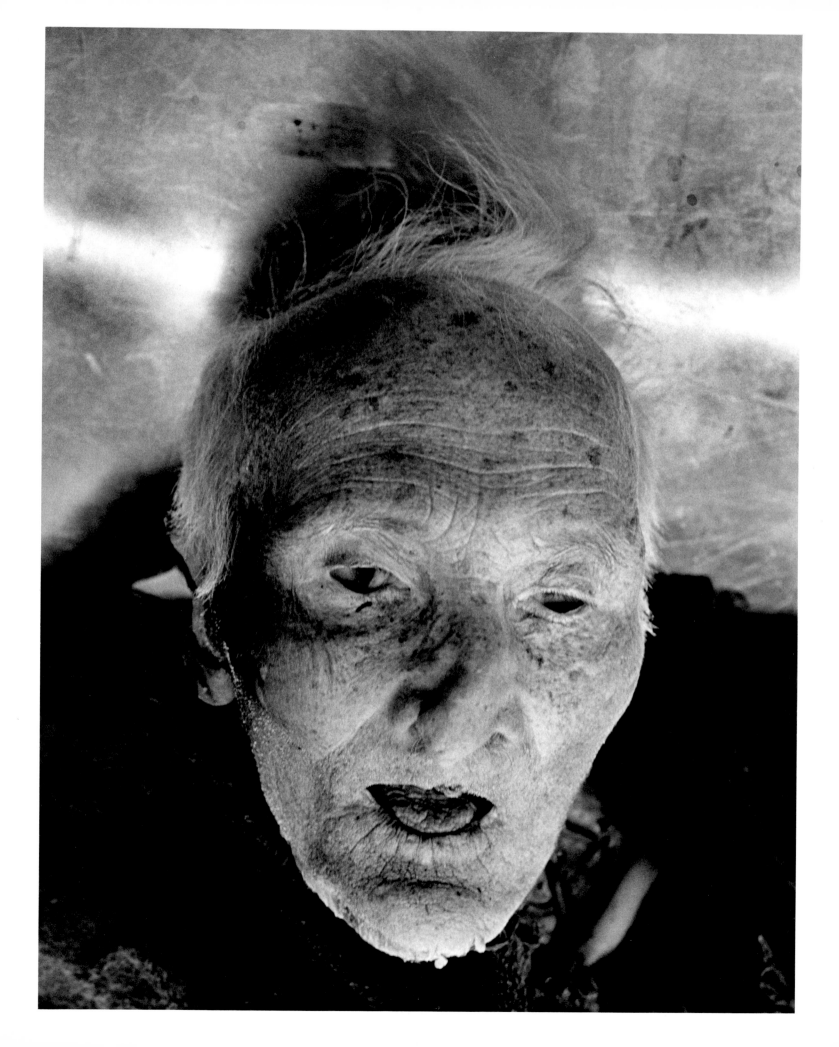

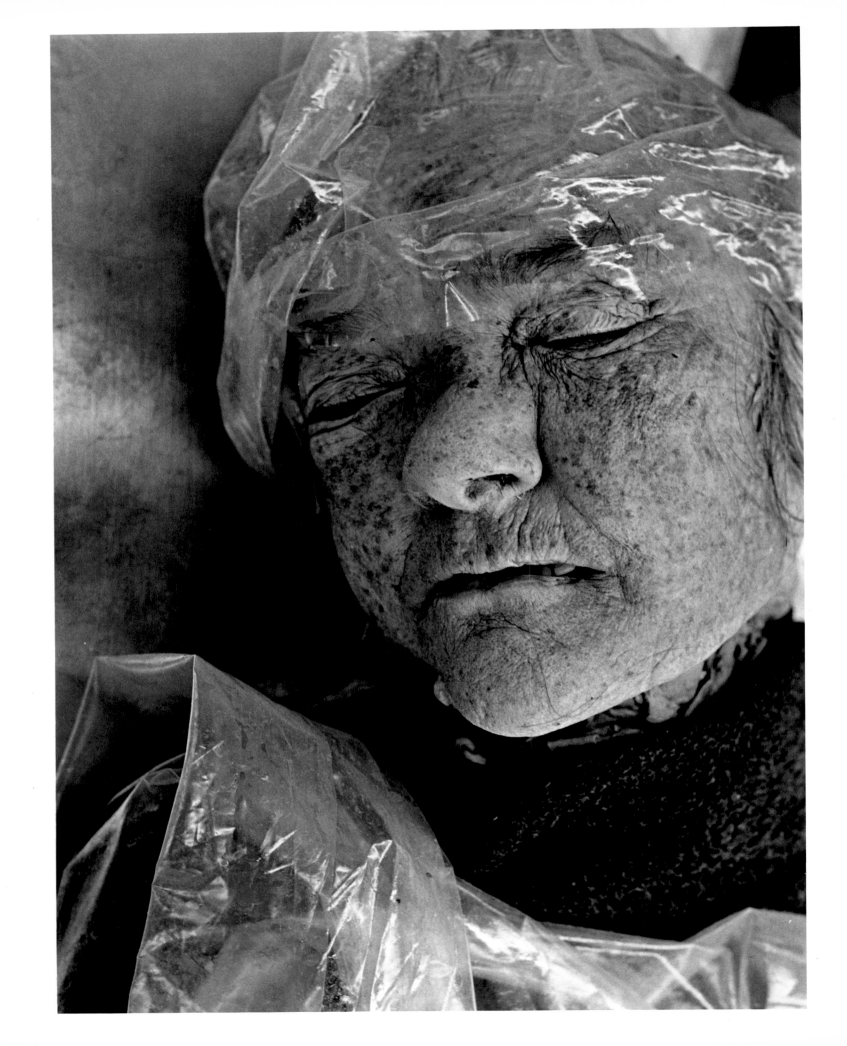

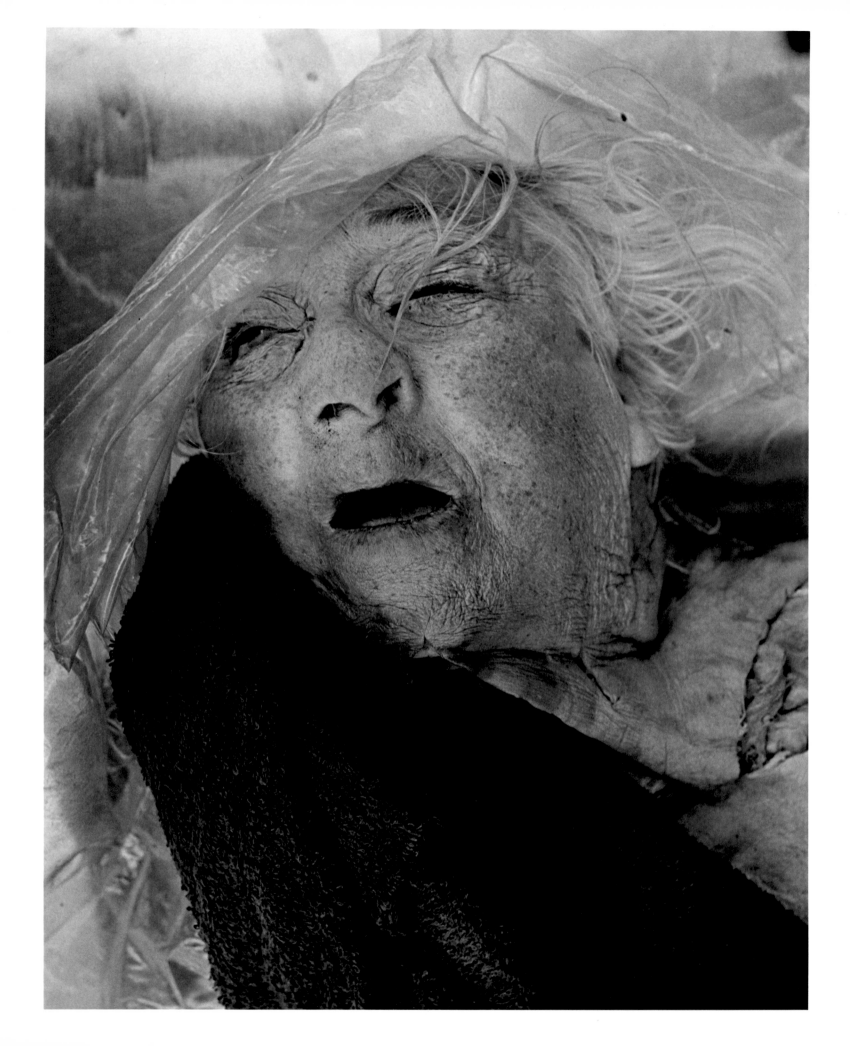

The human body has been depicted sculpturally from the earliest recorded time; invariably, these sculptures reflect symbolic needs of a given culture at a given moment.

The manikins I photographed in 1962 embodied a particular style and beauty of that time. They are stand-ins for an alleged truth, so skillfully manufactured that they reflect the very anxiety of the era in their detail.

Pages 83–85: *Manikins, 1962*

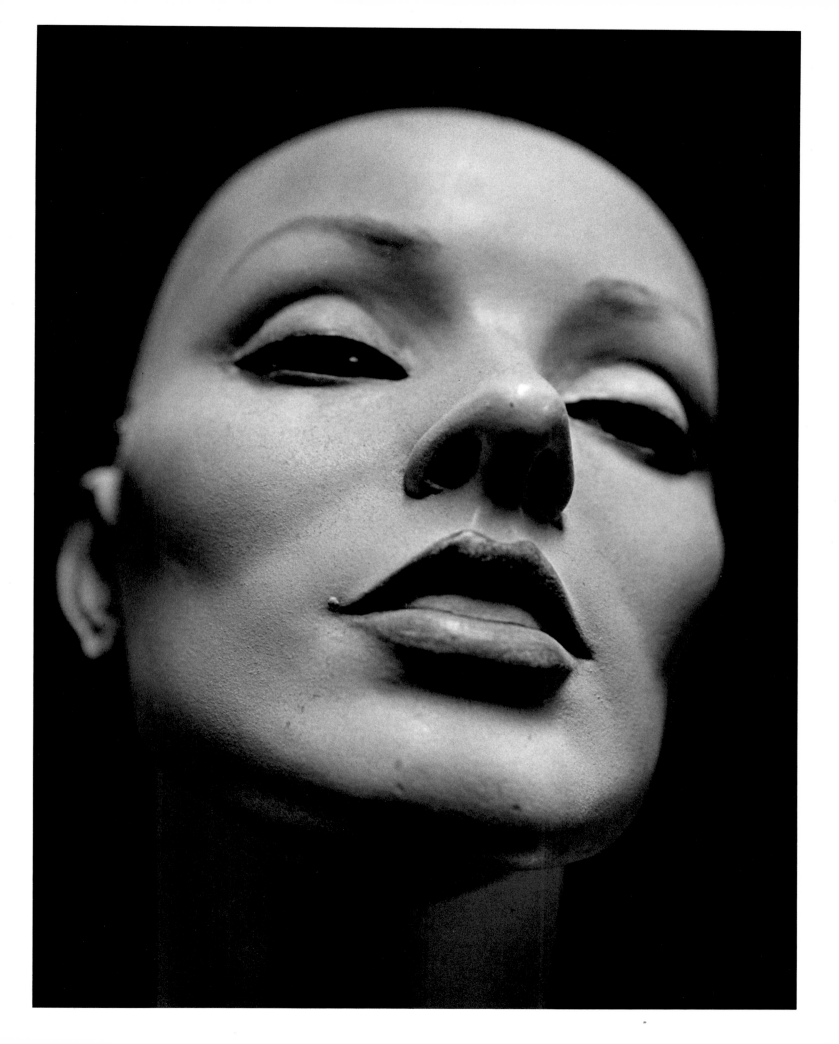

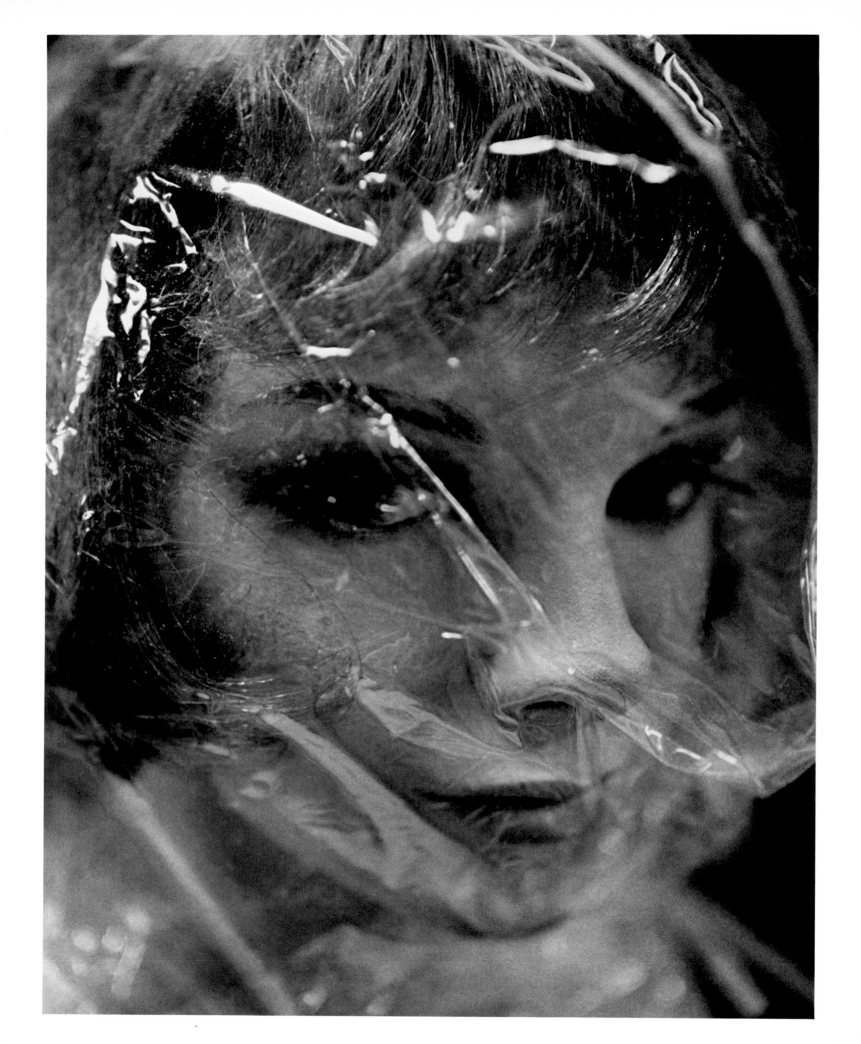

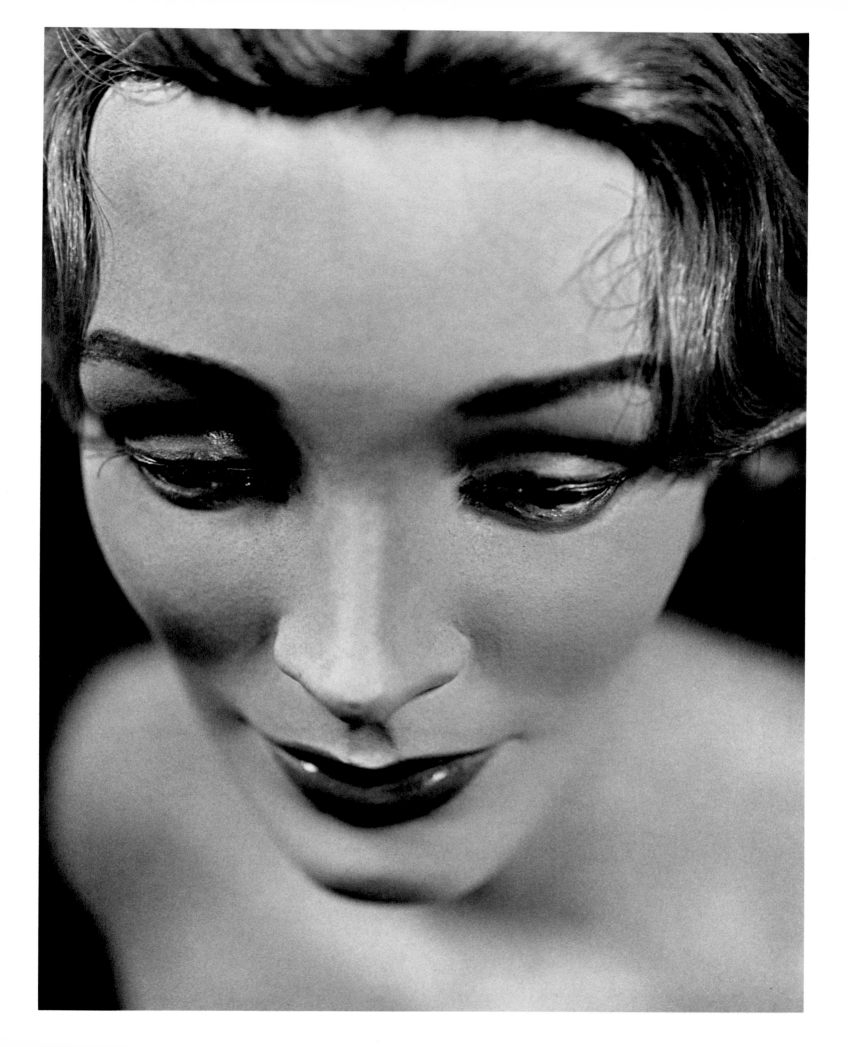

In 1950 I first visited the stockyards and slaughterhouses of South Saint Paul. I had been out of the army for five years, but my impressions and visions of the war were brought back vividly by the complex activity there; the dark, cavernous rooms and splattered walls, the wetness, the noise, and the huge number of animals killed.

A place charged with concepts—the pulsing of life and warm blood, continuously giving way to death and dismemberment— the slaughterhouse presented a jarring combination of mechanization, skill, commerce, food, and death. The pictures from there are tapestries: blood on walls, hands, and clothing; knives, pullies, bodies of animals; the concentration and skill of the workers; movement that almost never stopped.

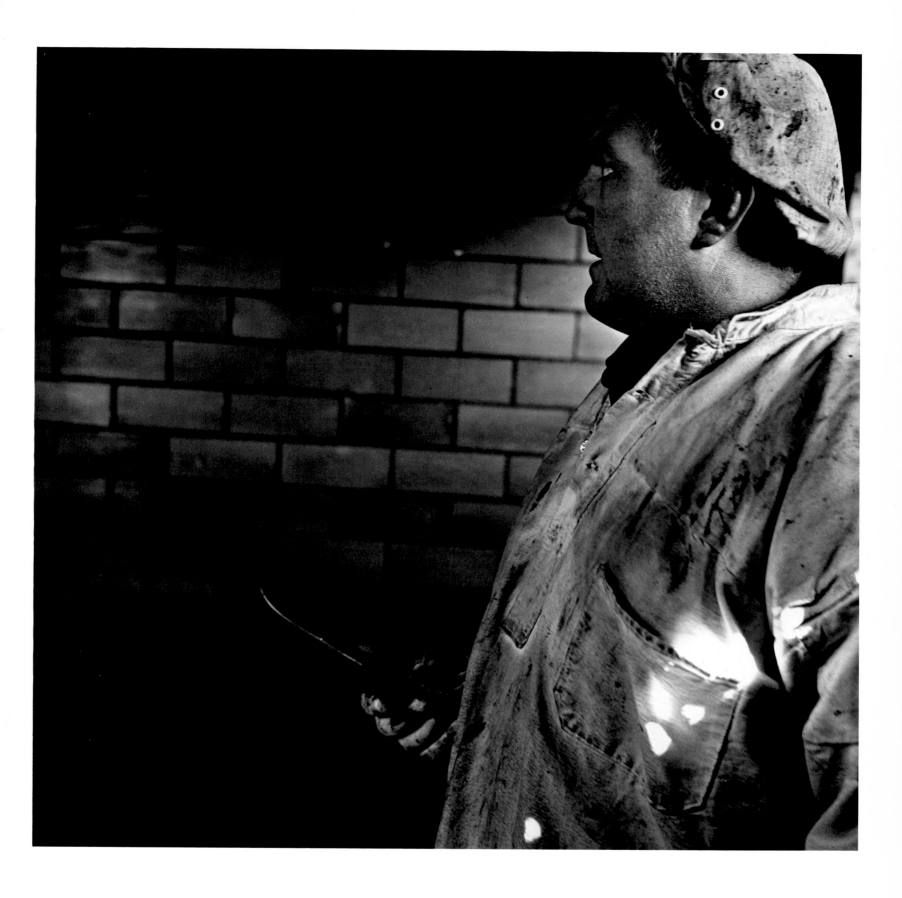

Pages 87–93: *Slaughterhouse*, South Saint Paul, Minnesota, 1962

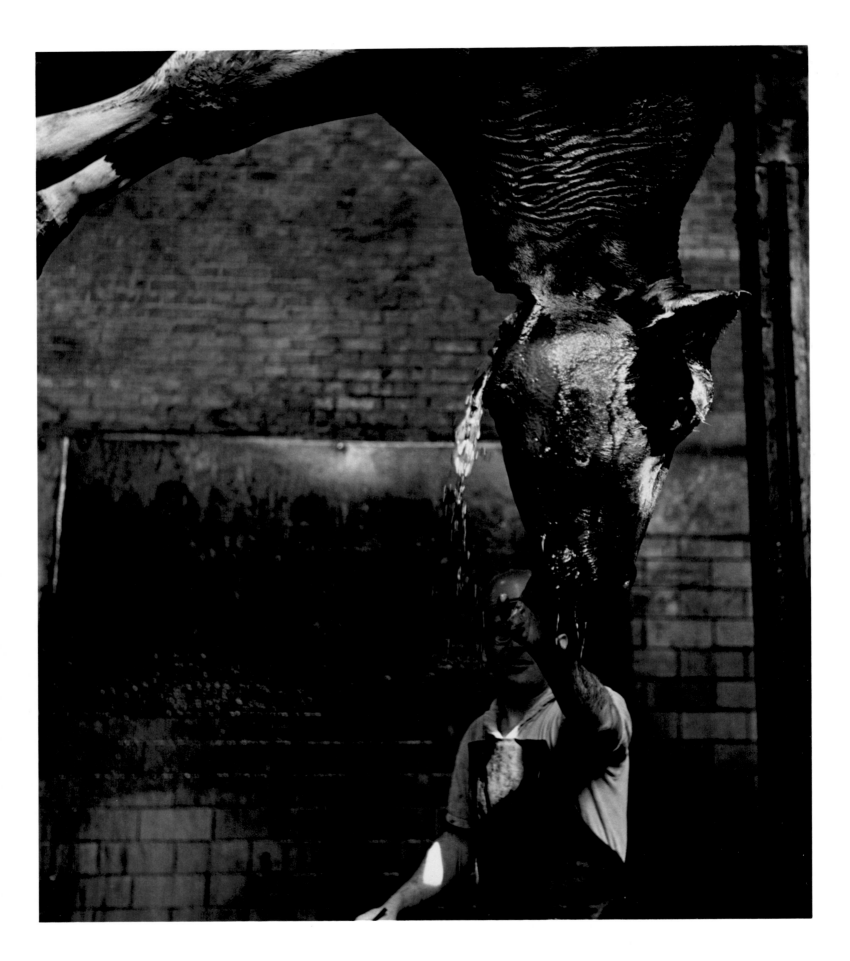

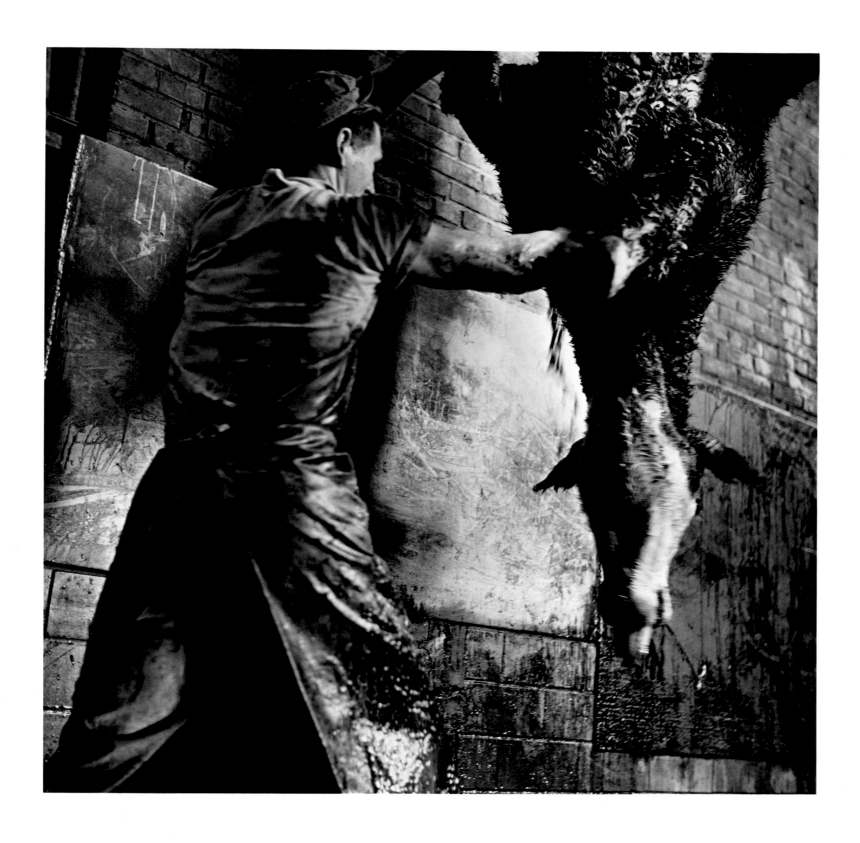

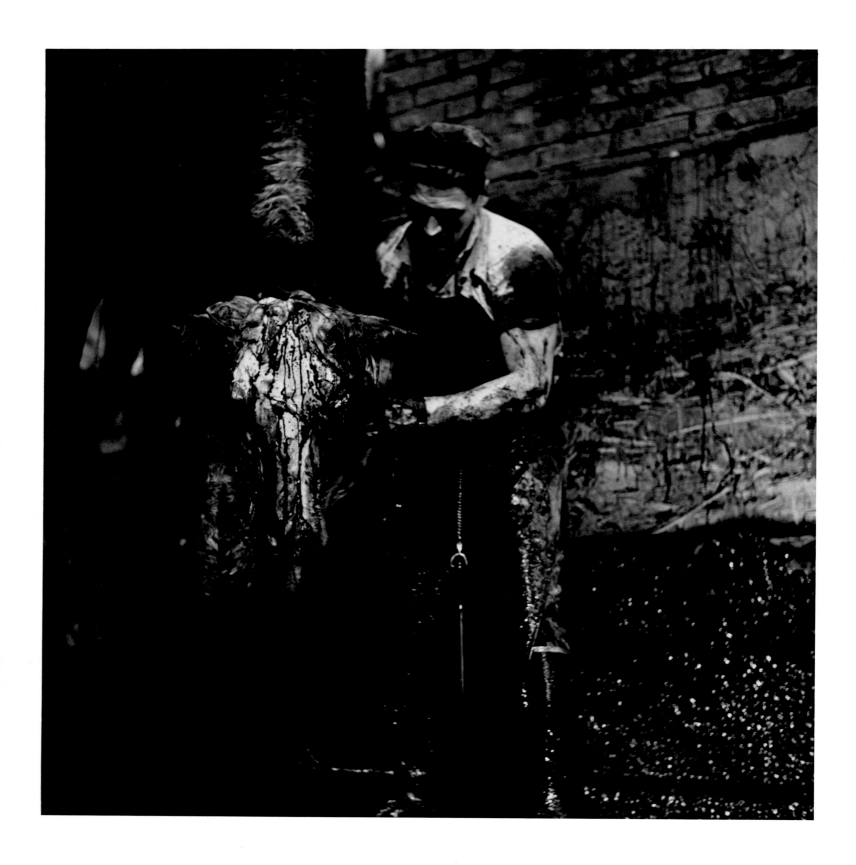

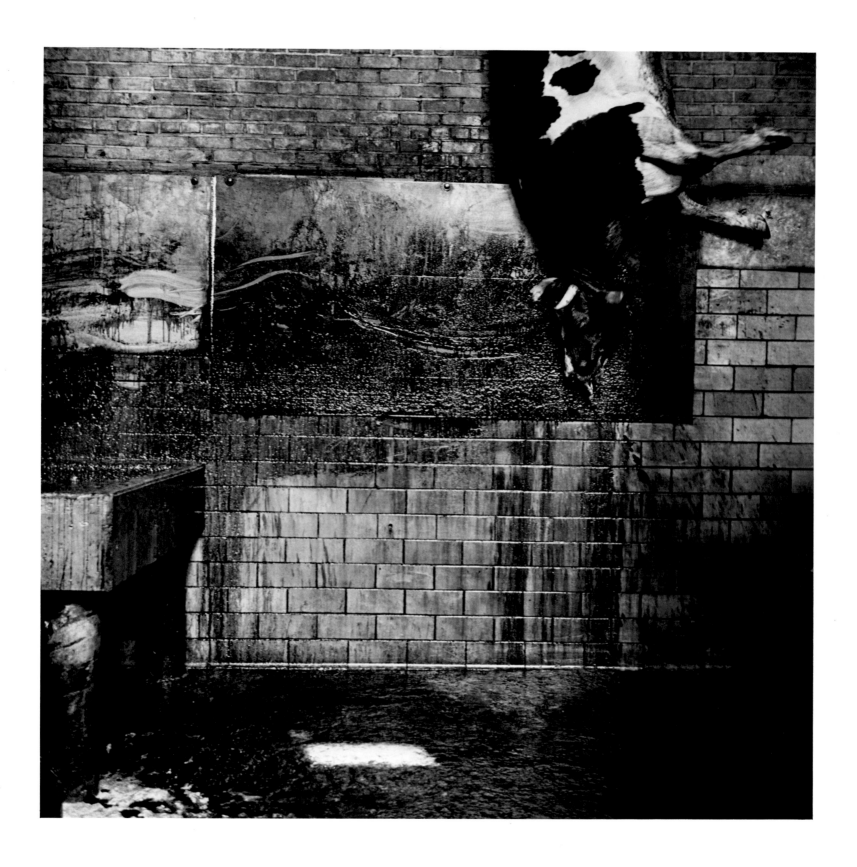

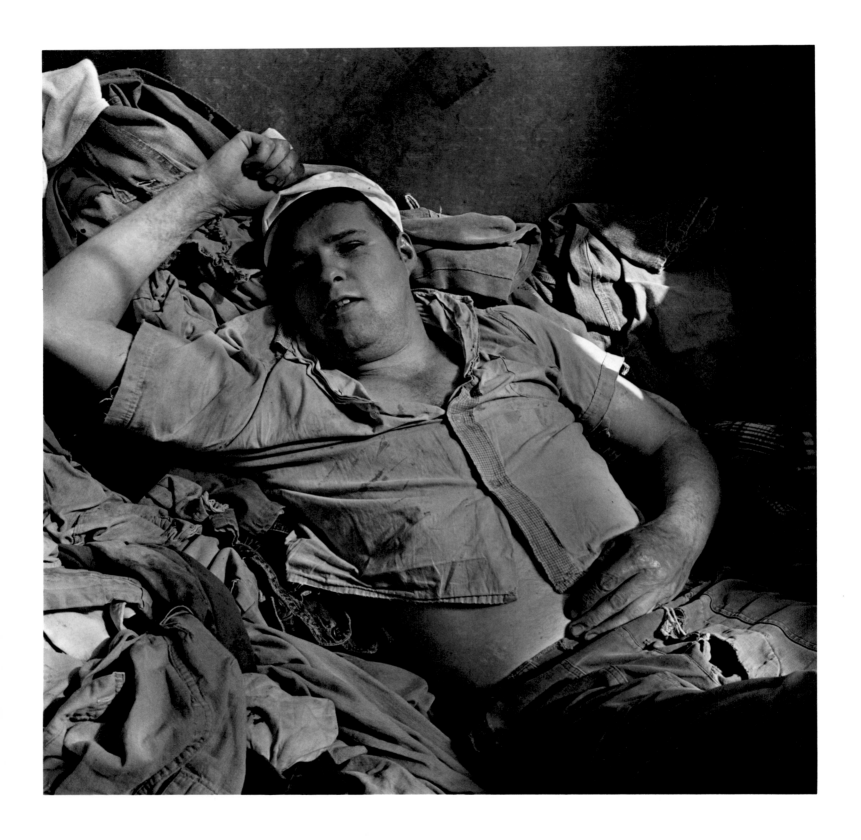

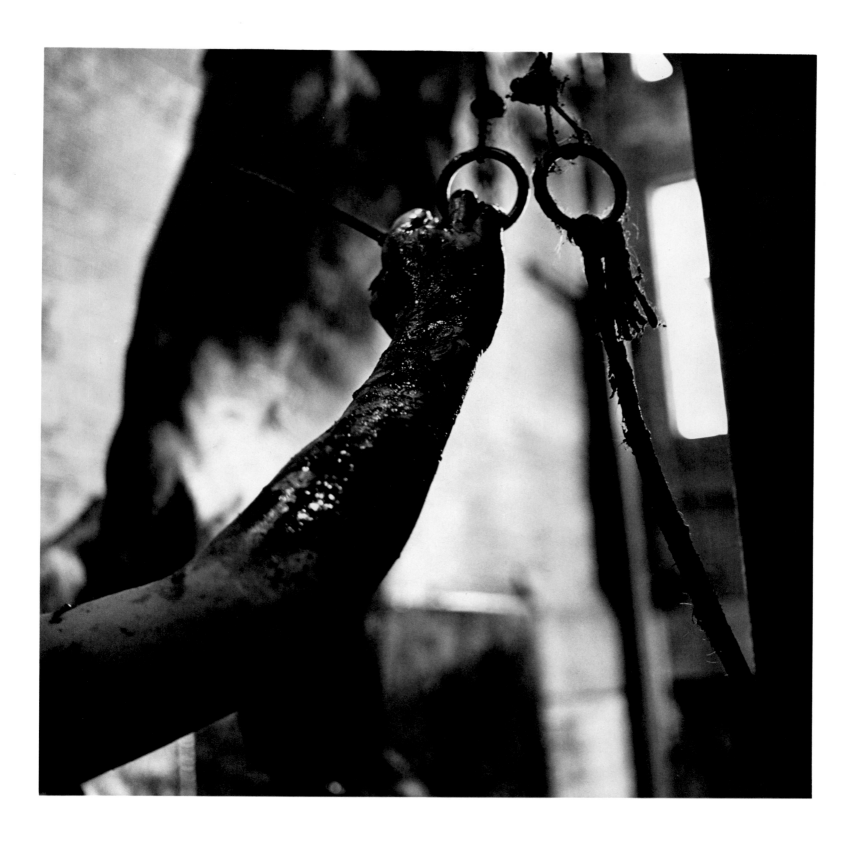

At the beginning of this century, all you needed to play handball were a rubber ball, a street, and a wall; the mastery of technique and the pleasure were free. As the decades passed, handball developed from a game into a sport, with indoor courts, and special sneakers and gloves.

My friend "Fast Eddie" Libman played handball all his life—he was still playing vigorously when he was in his eighties. The men in these photographs still wear their bumper sneakers and handmade gloves. The finesse, comradeship, and joy of the game are still very much there for them.

Now they have become gladiators of a sort, embodying all the valor that a life of physical movement, sweat, and great savvy bring to age.

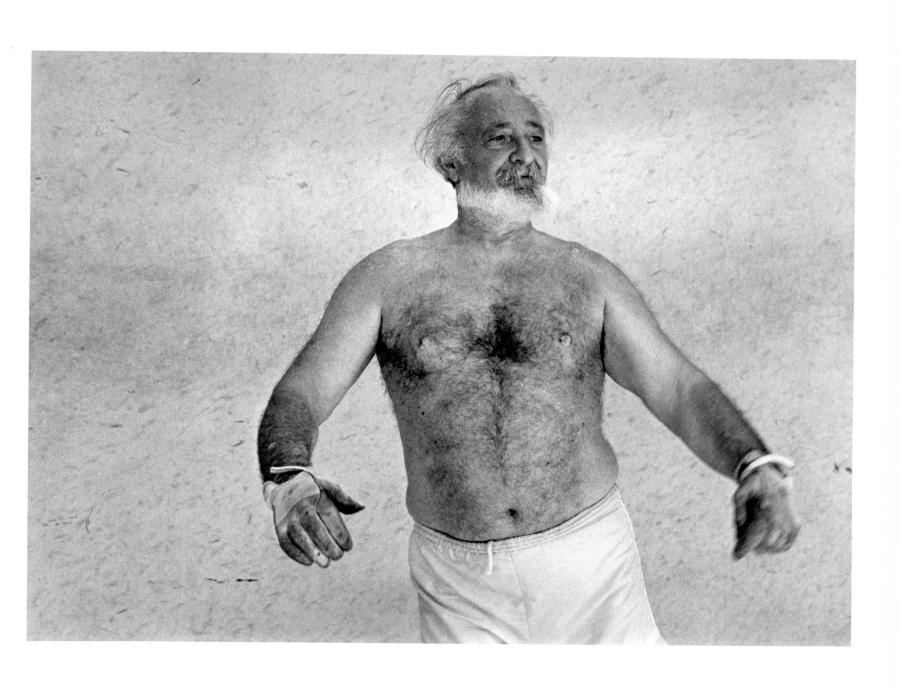

Handball Player, Miami Beach, Florida, 1978

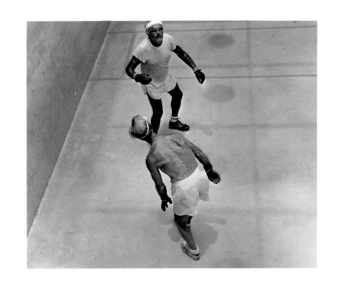

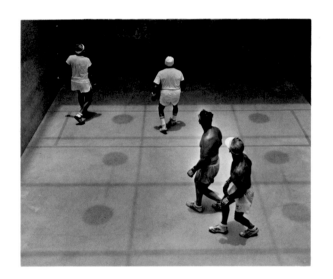

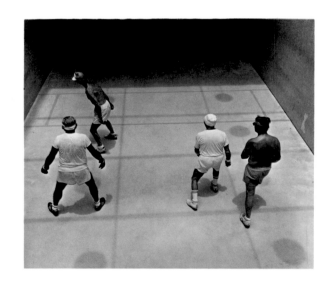

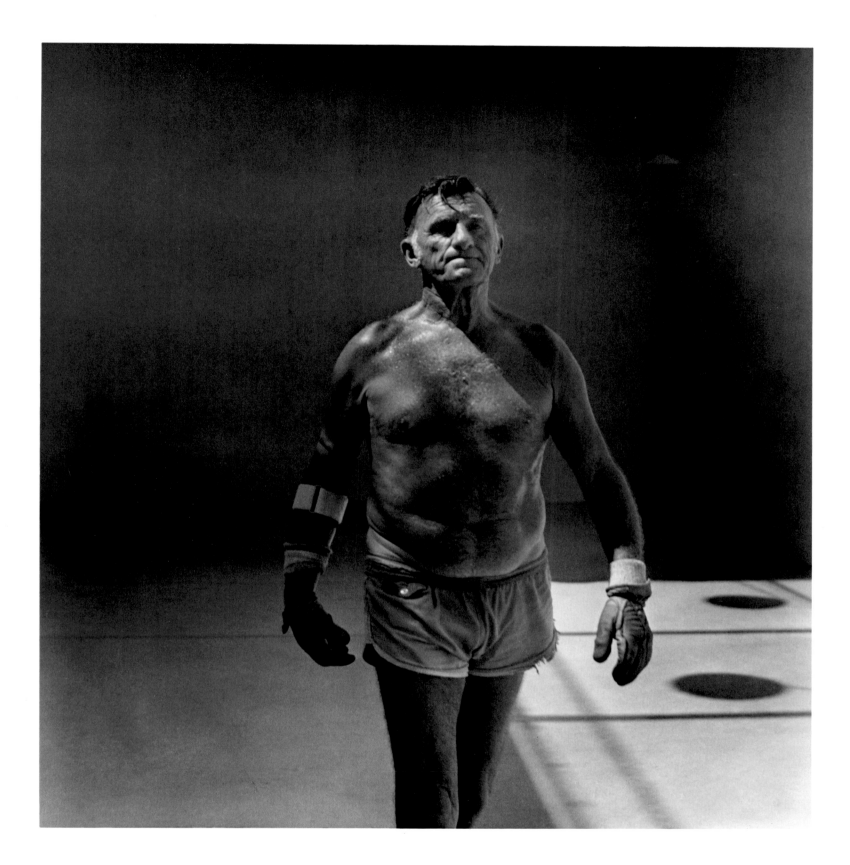

Opposite: All Miami Beach, Florida, 1975
Above: Eddie Libman, Miami Beach, Florida, 1977
Page 98: Miami Beach, Florida, 1977
Page 99: Miami Beach, Florida, 1978

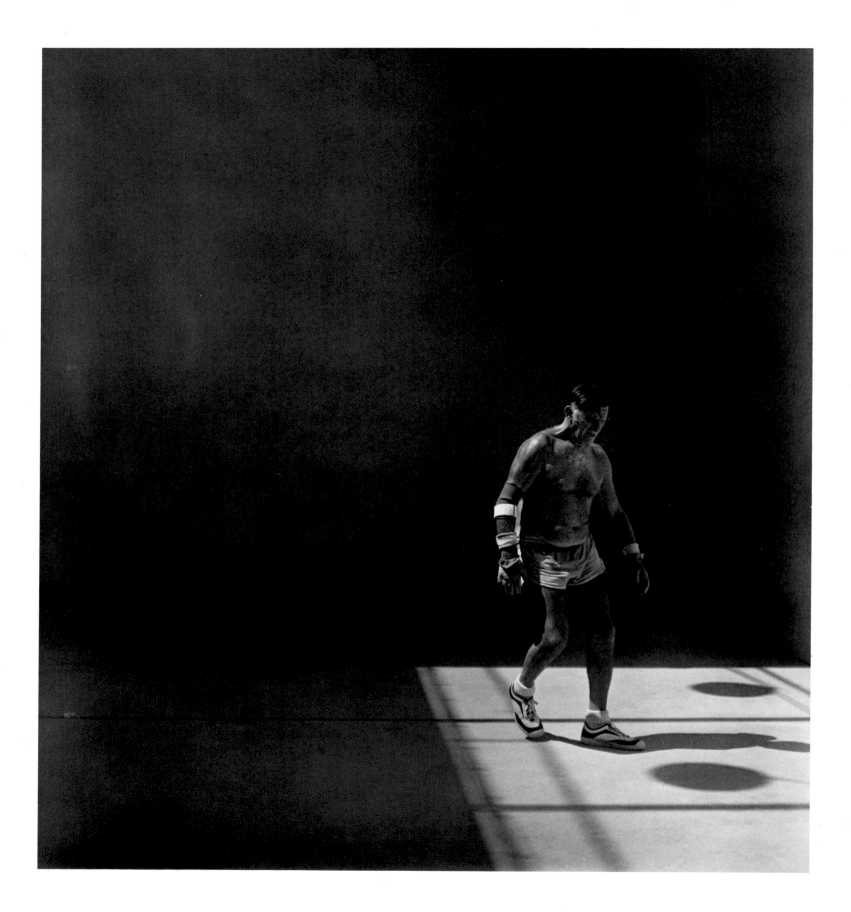

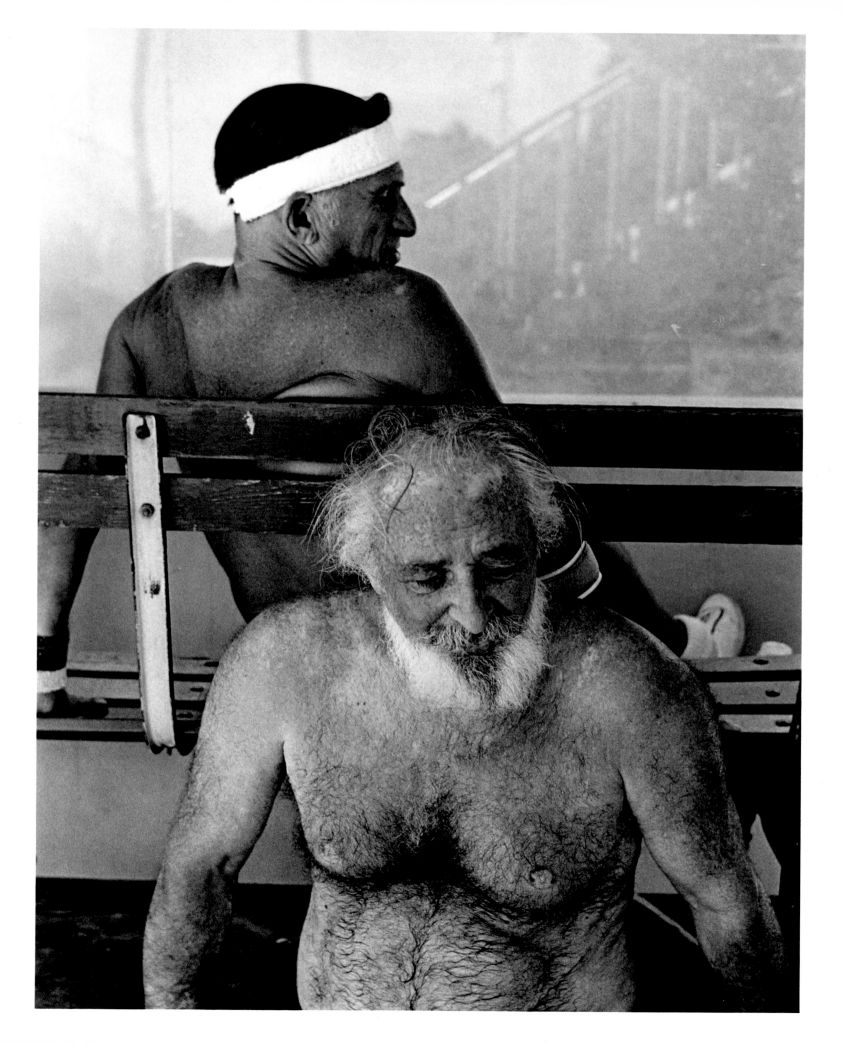

I photographed in clinics and institutions first in the 1960s, and then again in 1975, and was compelled by the remarkable strength of the people I saw. That strength is a personal, individual resource they call upon to provide some measure of balance in their lives—a personal compass they use to help them steer the way—to help them keep the chaos of their condition and of the world at bay. This extraordinary inner strength can be seen both in their faces and in their gestures.

I believe that the extent to which a society cares for all its people is a gauge of its humanity—or lack of it.

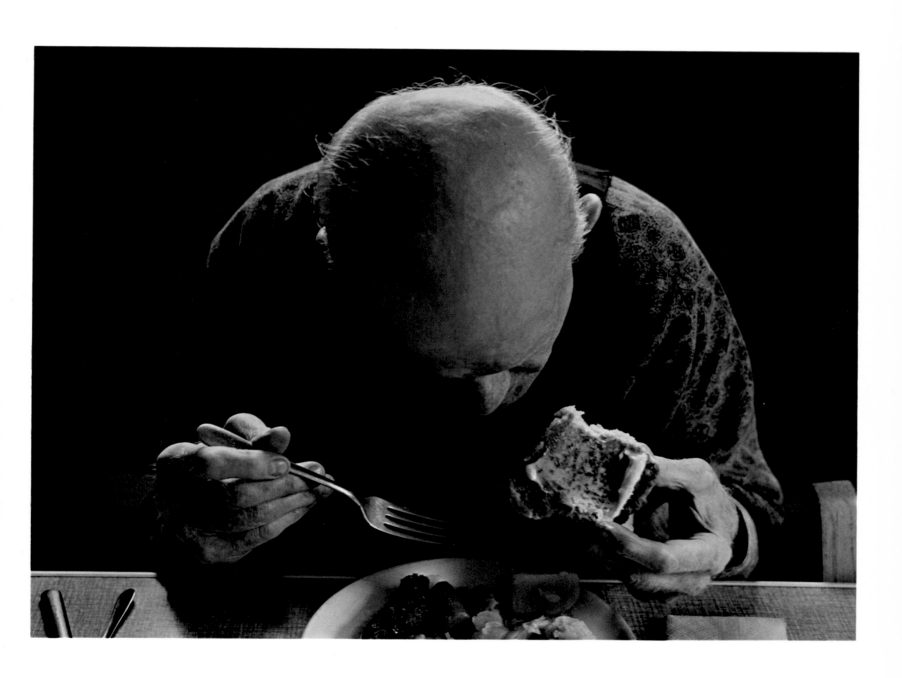

Blind Home, Saint Paul, Minnesota, 1961

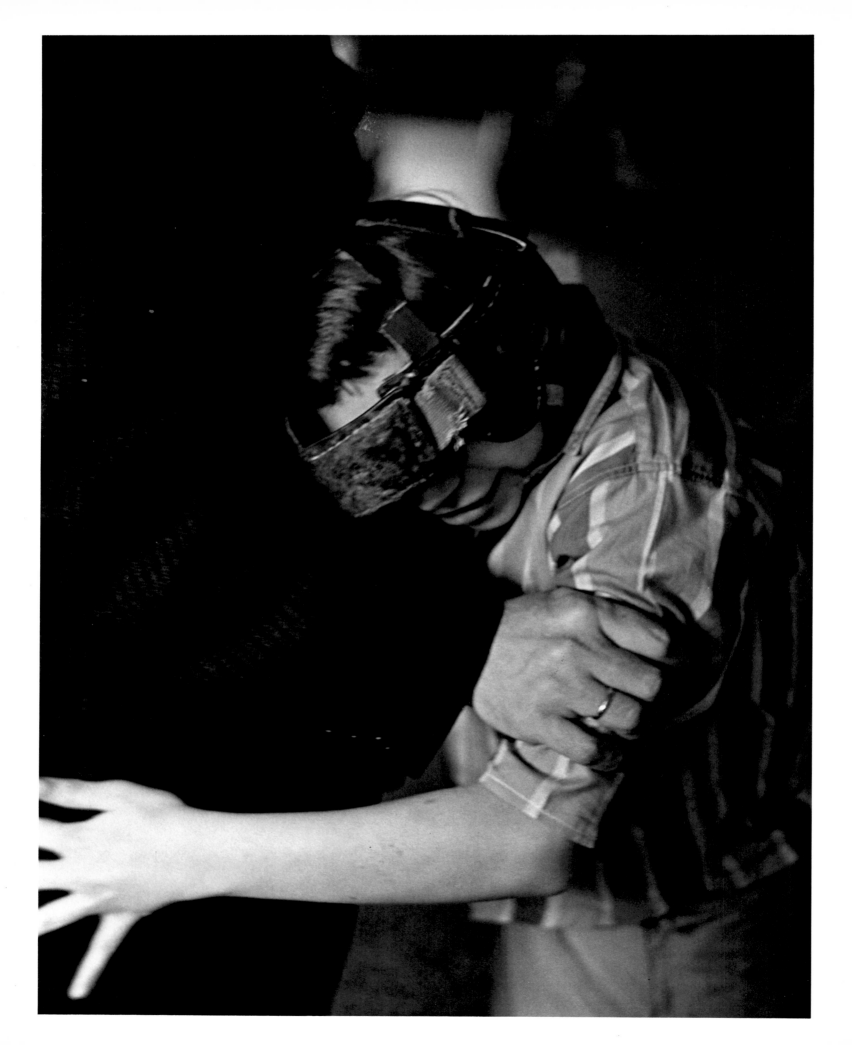

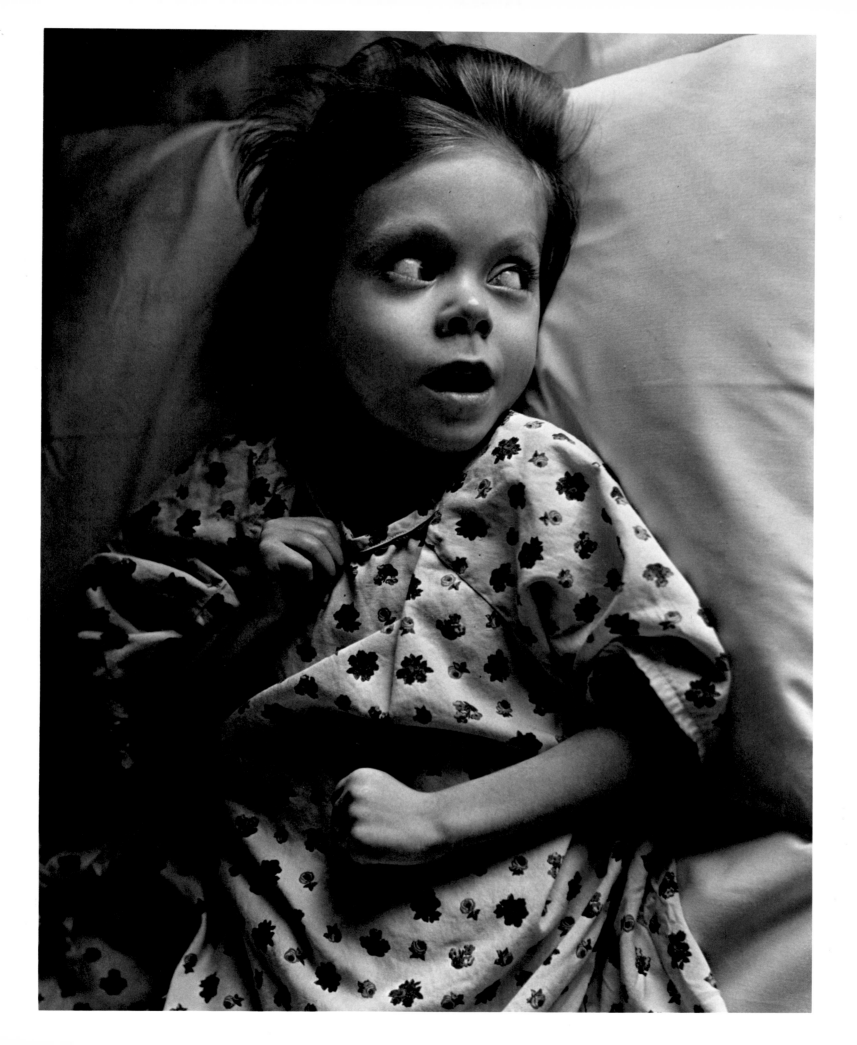

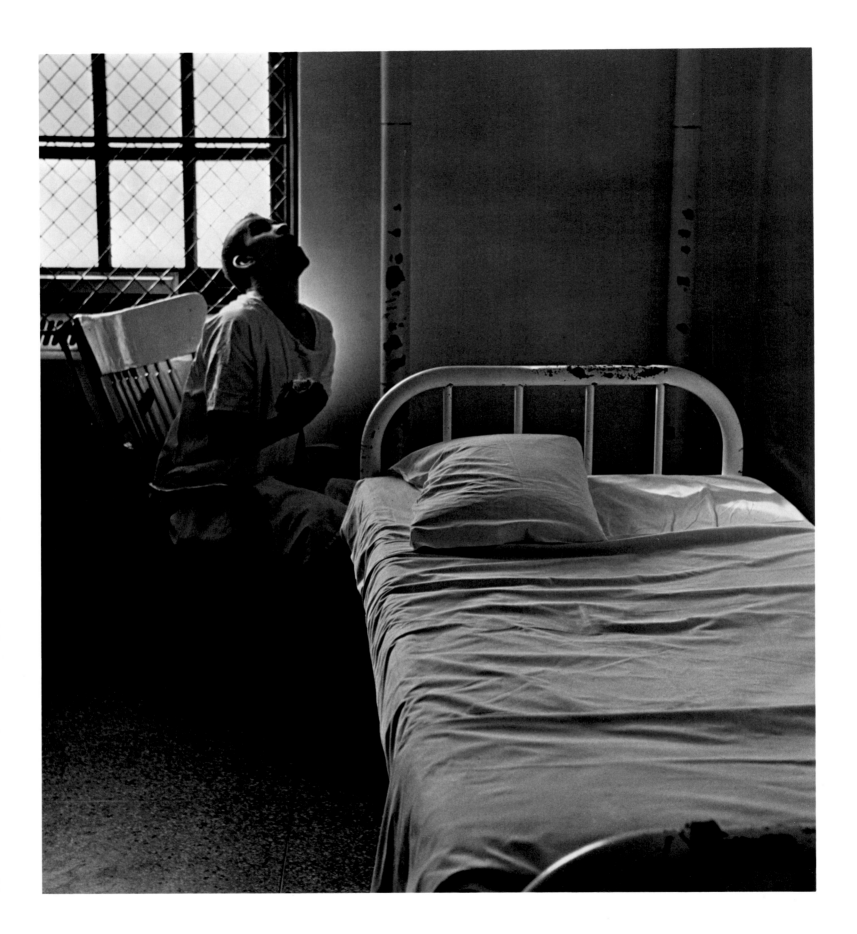

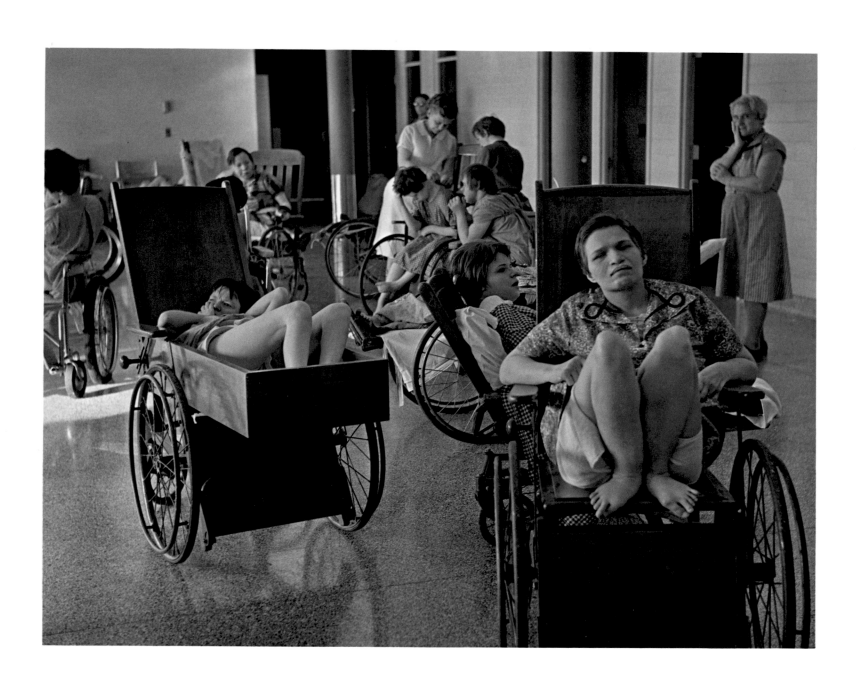

Pages 102–107: State Hospital, 1965

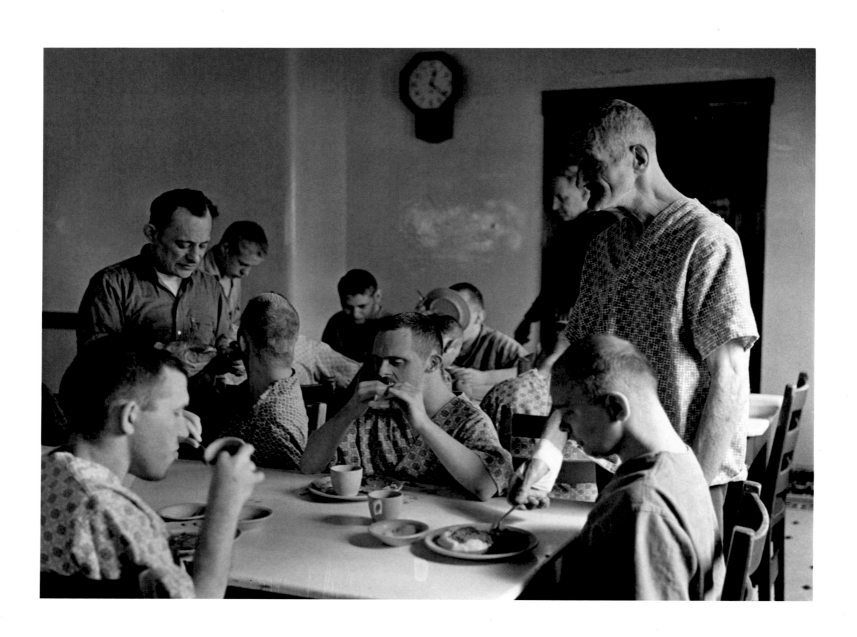

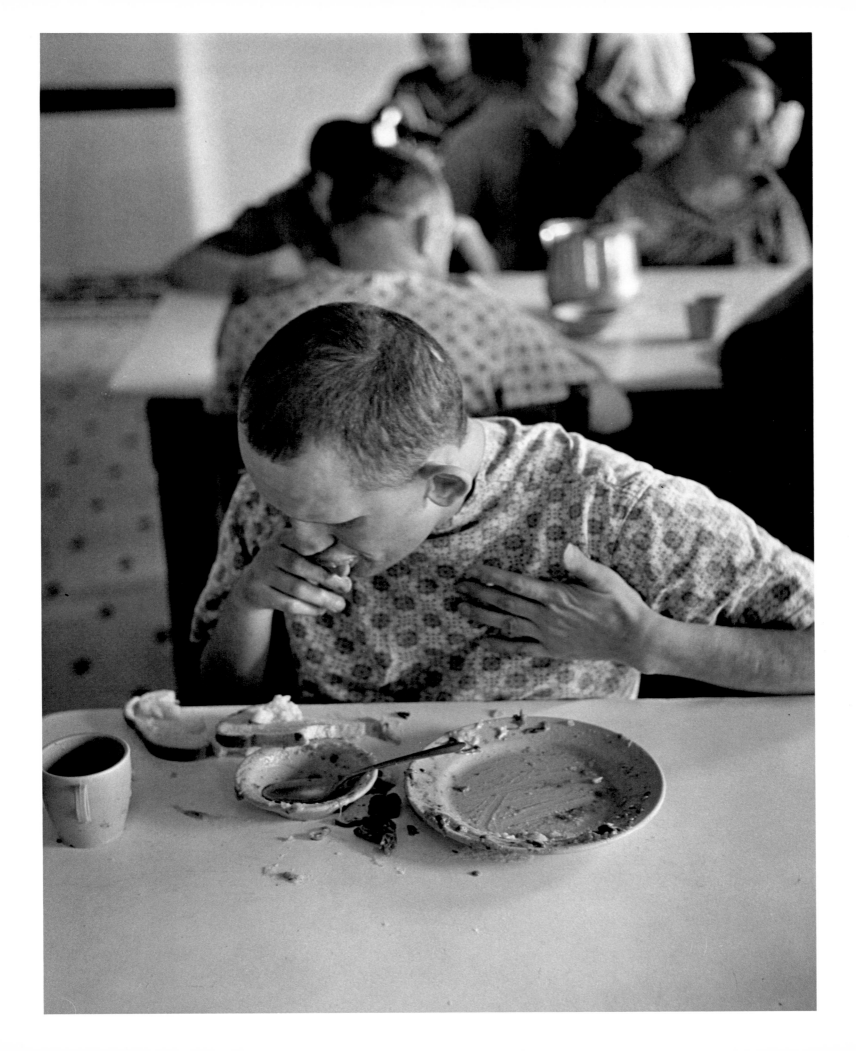

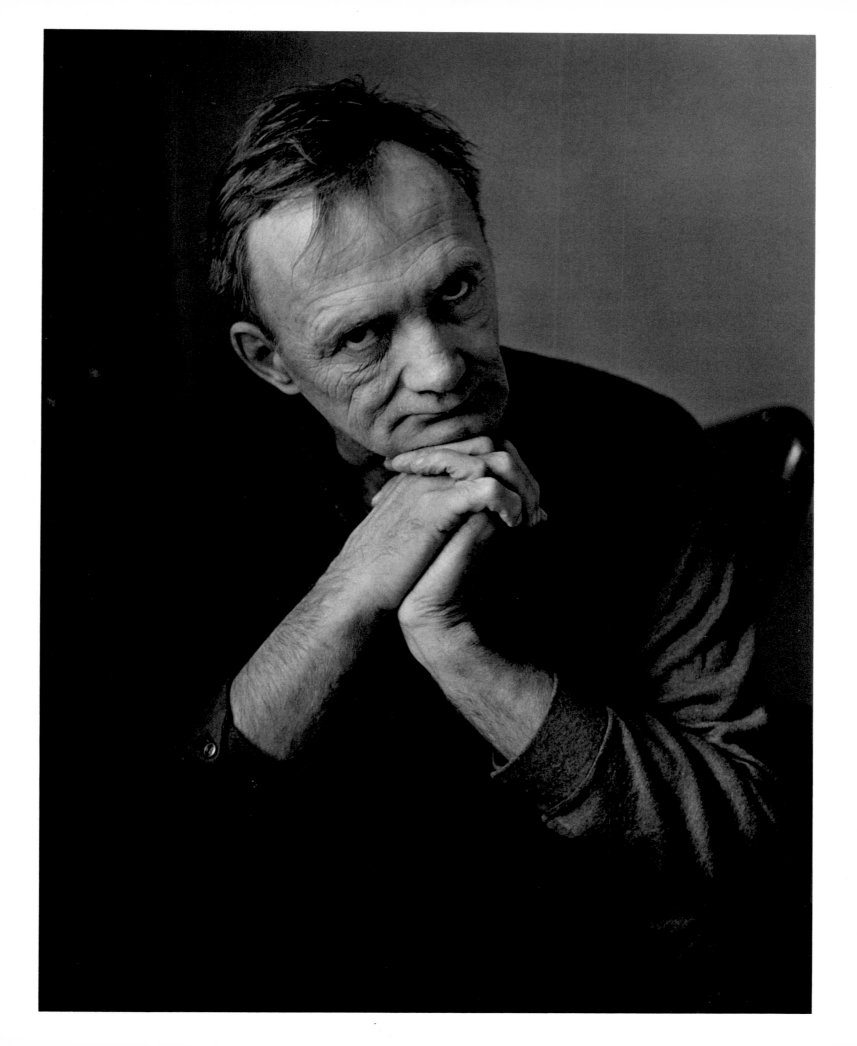

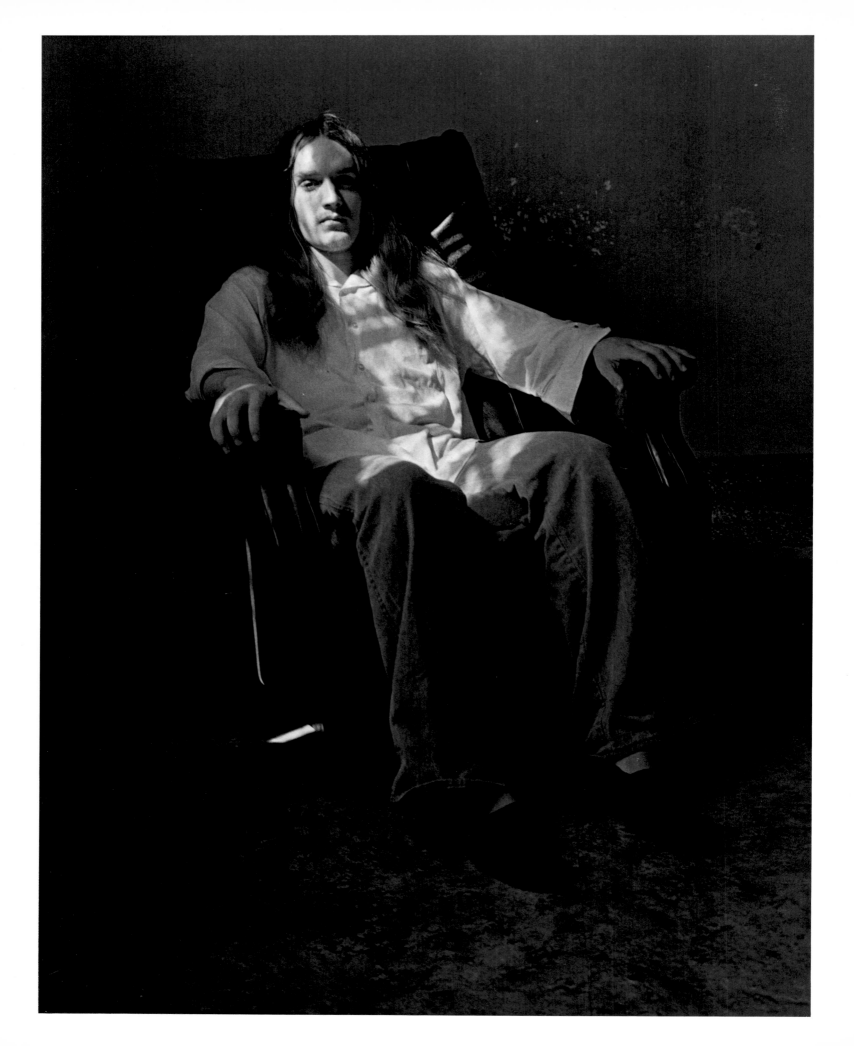

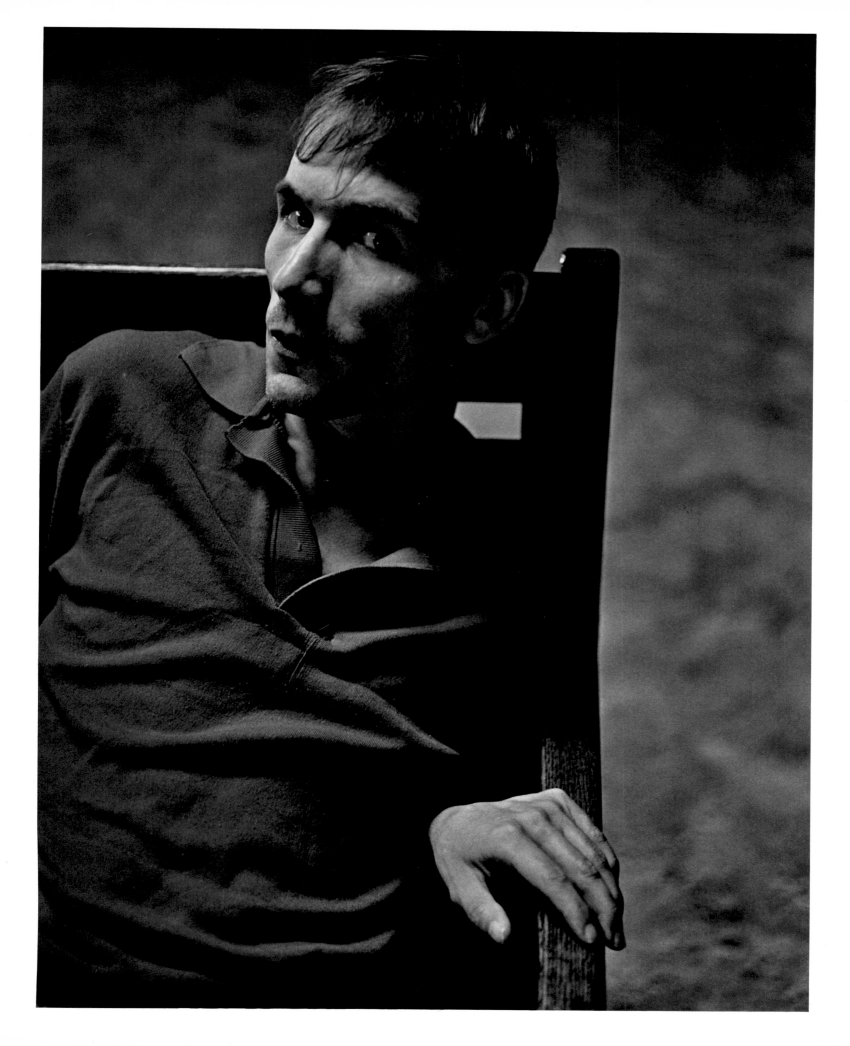

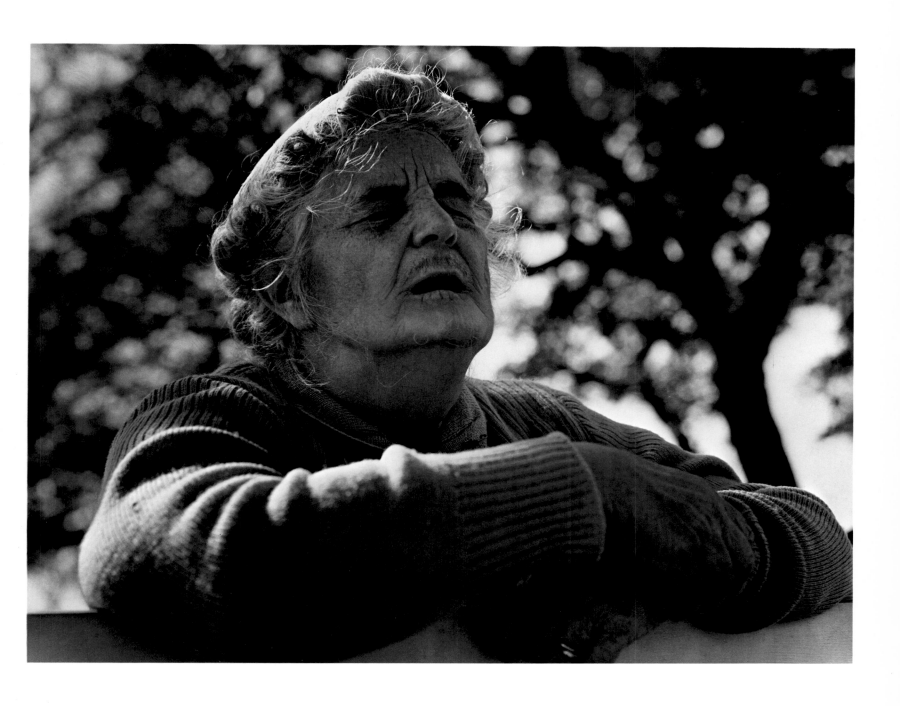

Pages 109–111: *State Hospital*, 1977
Above: *Blind Home*, Minnesota, 1961

113

Film and photography have worked in tandem in my life; each demands its own way of thinking, each has its own discipline and its own pace. The images that follow are from some of the documentary films I produced and directed.

The Tree is Dead, made with Allen Downs in 1953 at Red Lake, Minnesota, is a film about the Chippewa tribe—caught between the memories of their traditions and the poverty they suffered at the time the piece was made.

Pow Wow is, simply described, a loving and satirical look at a university marching band rehearsing in the rain—the moves and the music are interrupted by slips and slides in the downpour. Downs and I made the film in 1960.

89 Years is a film I completed in 1975; it focuses on Mrs. Soyak—eighty-nine years old—as she reminisces about her firstborn child. Interspersed with her memories are images of the newborn baby Leah Hanson.

In 1963 Downs and I made *The Old Men*, a study of the elders of the Blackfeet tribe in Browning, Montana. Fish Wolf Robe, Juniper Old Person, John Bird Earrings, and Leon Nation are tribesmen who remember the old ways and traditions of their people—still defiantly speaking in their native tongue and practicing the traditional religion.

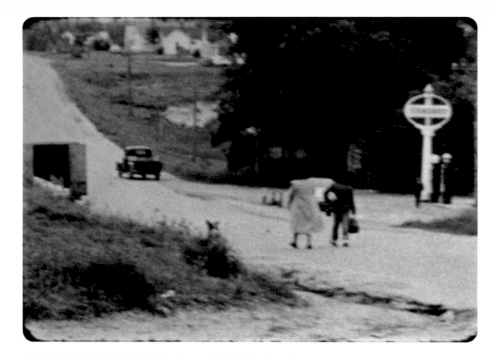

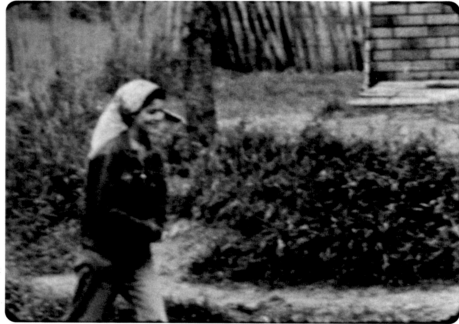

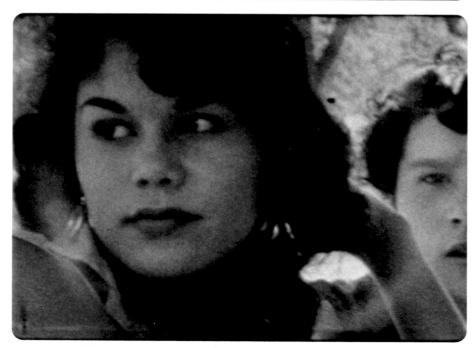

Stills from the film
The Tree is Dead 1953

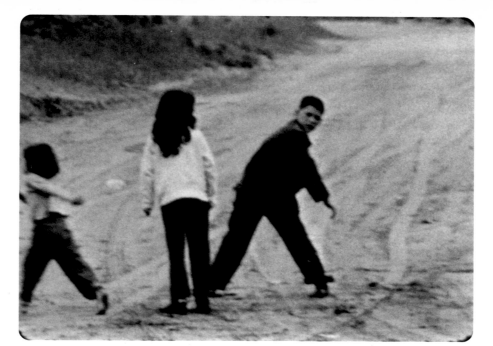

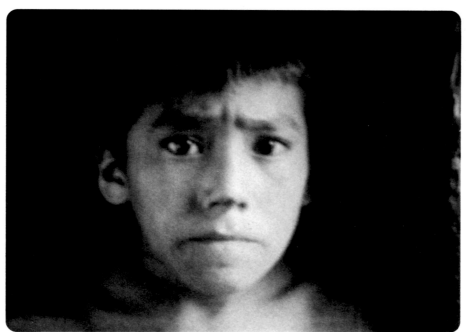

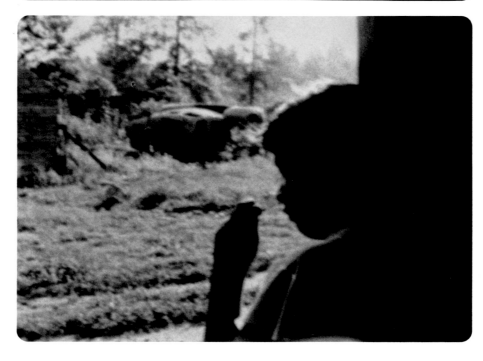

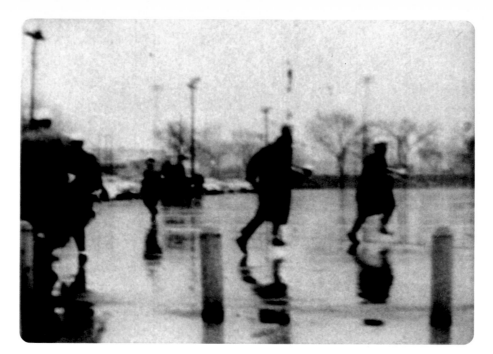

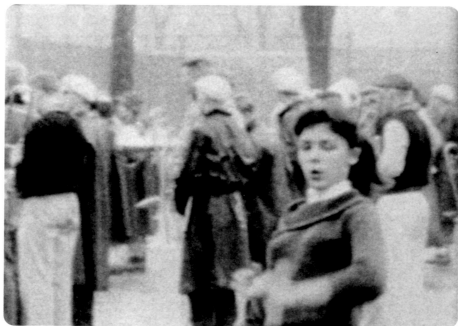

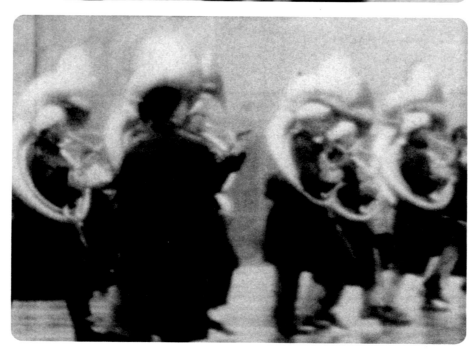

Stills from the film
Pow-Wow, 1960

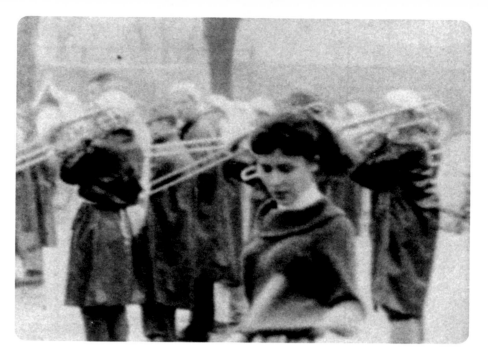

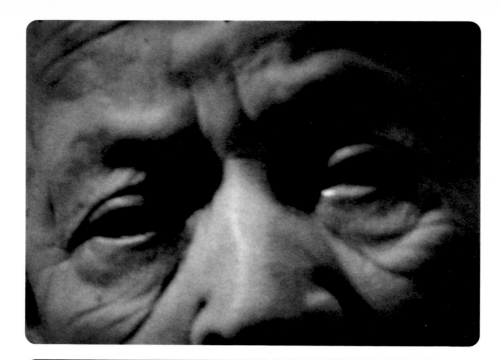

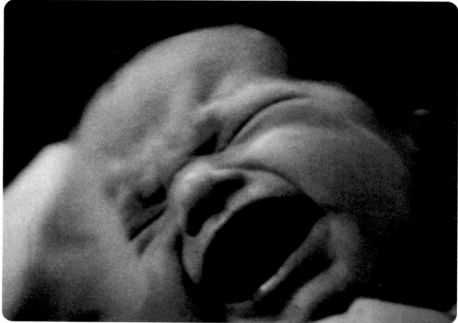

Stills from the film
89 Years, 1975

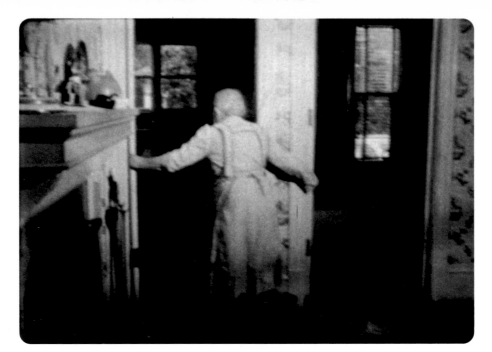

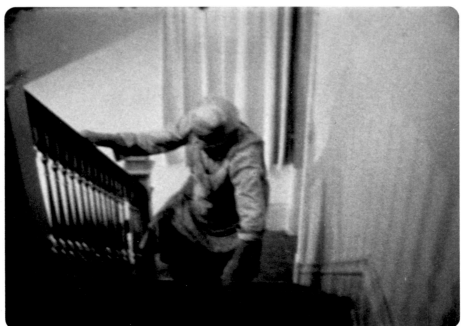

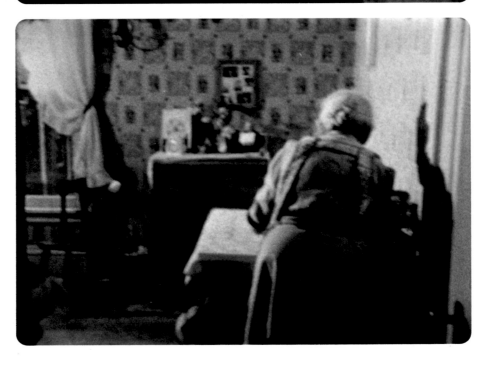

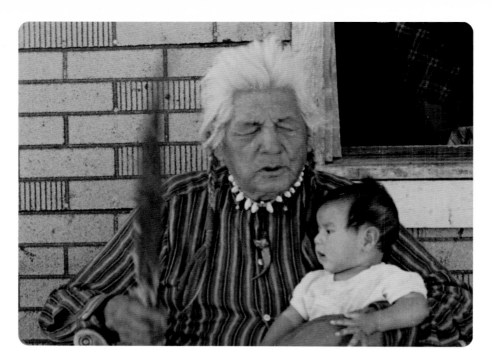

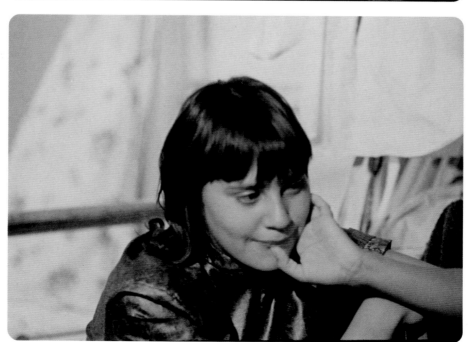

Stills from the film
The Old Men, 1963

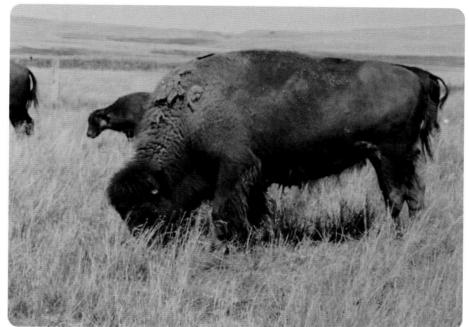

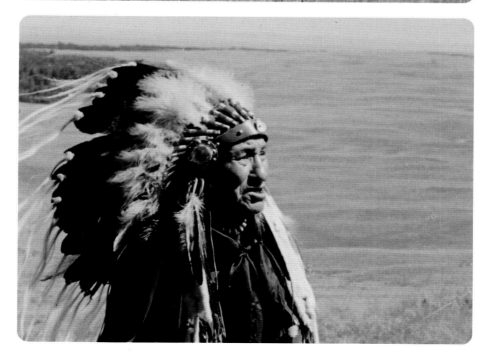

Chronology

April 16, 1924: Born New York City

1942: Enrolled at Brooklyn College, New York

1942–45: Served in U.S. Army, in North Africa and Europe

1946: After being released from army, returned to Brooklyn College. Studied art and design with Ad Reinhardt, Milton Brown, Burgoyne Diller, and Robert J. Wolf, and photography with Walter Rosenblum. Joined the New York Photo League as an executive officer; studied with Paul Strand, and became closely associated with the League's members, including W. Eugene Smith, Dan Weiner, Lisette Model, Aaron Siskind, Beaumont and Nancy Newhall.

1948: Studied motion-picture production at the New School for Social Research in New York, with Arthur Knight, Raymond Spottiswoode, and Leo Hurwitz.

1949: Marriage to Phyllis Levine. (Over the following years, the couple had five children: Madeleine, Tina, Adam, Daniella, and Rachel.) Appointed professor of film and photography at the University of Minnesota, Minneapolis.
First solo exhibition, at Minneapolis's Walker Art Center.

1951: Together with Allen Downs, produced the film *Art and Seeing*. Liebling and Downs would continue to collaborate on films for thirteen years.

1953: *Art and Seeing* received Screen Producers Guild award.

1955: Liebling and Downs made *The Tree is Dead*, a documentary about the Native Americans of Red Lake, Minnesota.

1956: Received New Talent USA Award from the American Federation of Art.

1957–58: Taught as professor of film and photography at the State University of New York, New Paltz. Solo exhibition at the International Museum of Photography, George Eastman House, Rochester, NY.

1960: Liebling and Downs produced the film *Pow-Wow*, which won numerous awards over the next two years.

1961: Cofounder of the Society for Photographic Education.

1964: *The Tree is Dead* received Documentary Prize, Festival dei Popoli, Florence, Italy

1965: Liebling and Downs produced the documentary *The Old Men*, a study of the Blackfeet Indians of Montana. *The Face of Minneapolis*, a book of Liebling's photographs with text by Don Morrison, was published by Dillon Press.

1966: Produced and directed *They Need These Days*, documentary on child care in Minnesota, for the Minnesota Department of Public Welfare.

1967: Liebling's work featured in "The Camera as Witness" exhibition at Expo '67, Montreal.

1969: Appointed professor of film studies at Hampshire College, Amherst, Massachusetts.

1971: Organized Summer Film Institute at Hampshire College (1971–1981). Appointed vice-president of University Film Studies Center.

1975: Completed the film *89 Years*, a portrait of 89-year-old Mrs. Soyak and six-day-old Leah Hanson. Received Massachusetts Arts and Humanities Foundation Fellowship.

1976–77: Appointed first Walker Evans Visiting Professor of Photography at Yale University, New Haven, Connecticut.

1977: Received Guggenheim Foundation grant. Friends of Photography published *Monograph 15*, devoted to the work of Liebling. Portfolio of his photographs appeared in *Aperture #78*.

1978: Publication of *The Photography of Jerome Liebling, 1947–1977*, text by Estelle Jussim. Retrospective exhibition at Friends of Photography, Carmel, California. Liebling's work was featured in several traveling shows this year, including: "Photographic Crossroads: The Photo League" at the National Gallery of Canada, Ottawa (traveled to the International Center of Photography, New York; the Museum of Fine Arts, Houston; and the Minneapolis Institute of Fine Arts); "Photos from the Sam Wagstaff Collection" at the Corcoran Gallery of Art in Washington, D.C. (toured the United States, Canada, and Europe); and "Mirrors and Windows: American Photography Since 1960" at New York's Museum of Modern Art (toured the United States).

1979: Edited the *Massachusetts Review* photography issue, distributed by Light Impressions as *Photography: Current Perspectives*. Received grant from the National Endowment for the Arts.

1980: "Jerome Liebling, Photographs" exhibition at the Corcoran Gallery of Art in Washington, D.C., accompanied by catalog with text by Jane Livingston. Awarded NEA Photographic Survey grant.

1981: Received second Guggenheim grant. Work featured in the exhibition "American Children," at New York's Museum of Modern Art.

1982: *Jerome Liebling Photographs*, monograph with essays by Alan Trachtenberg and Anne Halley, published by the University of Massachusetts Press. Exhibition "Contemporary Color: Jerome Liebling," at the Fogg Art Museum, Harvard University, Cambridge, Massachusetts.

1984: Received fellowship from the Massachusetts Council of the Arts.

1985: Work featured in the exhibition "American Images 1945–80," at the Barbican Art Gallery, London (toured in Britain).

1988: *Jerome Liebling Photographs* published by Aperture. Worked with daughter Rachel Liebling and Andrew Serwer on the film *High Lonesome*, a documentary on the history of bluegrass music.

1989: Received honorary Doctor of Law degree from Portland School of Art, Portland, Maine.

1990: Marriage to Rebecca Nordstrom.

1992: Work included in the exhibition "Flora Photographica," at the Serpentine Gallery, London (toured throughout the United Kingdom and Canada).

1993: Liebling, Roger Sherman, and Buddy Squires produced the film *Fast Eddie and the Boys*, which received first prize for the 1993 New England Film Festival award.

1994: Work included in the exhibition "American Politicians," at New York's Museum of Modern Art (traveling throughout the United States).

Work included in the exhibition "American Photographers 1890–1965 from the Museum of Modern Art, New York," opening at the Kunstbibliothek Staatliche Museen zu Berlin, Germany (traveling throughout Europe).

Liebling lives in Amherst, Massachusetts, and is currently Professor Emeritus at Hampshire College. He continues to work with former students in filmmaking, including Ken Burns, Buddy Squires, and Roger Sherman.

The exhibition and publication of The People, Yes *are dedicated to the memory of Hall James Peterson. Hall and his wife Kate Butler Peterson were the founding benefactors to the collection of fine photographs at the Minneapolis Institute of Arts. Hall's acquaintance with Jerome Liebling and his work make this a fitting memorial to his abiding enthusiasm and generosity.*

This book and the accompanying exhibition have been made possible through the generous support of the Patrick and Aimee Butler Family Foundation, Saint Paul, Minnesota.

Acknowledgments

I would like to express my deep gratitude to my wife Rebecca Nordstrom, Mark and Cheryl Liebling, Dan and Phyllis Wiener, Lawrence and Lee Gray, Ken Burns, Jane and Gerald Katcher, Carroll T. Hartwell of the Minneapolis Institute of Arts, David Chandler of the Photographers' Gallery in London, Howard Greenberg of the Howard Greenberg Gallery in New York City, and Michael E. Hoffman and Diana Stoll of Aperture.

And my thanks are extended also to the following institutions: The Amherst History Museum, Amherst, Massachusetts; The Boston Public Library, Boston, Massachusetts; Emily Dickinson House, Amherst, Massachusetts; Ralph Waldo Emerson House, Concord, Massachusetts; The Fogg Art Museum, Cambridge, Massachusetts; Isabella Stewart Gardner Museum, Boston, Massachusetts; Harriet Beecher Stowe House, Hartford, Connecticut; Mark Twain House, Hartford, Connecticut.

Aperture gratefully acknowledges the generous support of
The Minneapolis Institute of Arts and The Photographers' Gallery, London.

PRINTS OF BOSTON, MASSACHUSETTS, 1984 (PAGE 27)
AND MORNING, MONESSEN, PENNSYLVANIA, 1983 (PAGES 38–39)
ARE AVAILABLE THROUGH APERTURE IN LIMITED EDITIONS
OF 30 PRINTS EACH, SIGNED AND NUMBERED BY JEROME LIEBLING AND
ACCOMPANIED BY A SIGNED COPY OF THE PEOPLE, YES.

A TRAVELING EXHIBITION OF "THE PEOPLE, YES" WILL OPEN IN THE
UNITED STATES AT THE MINNEAPOLIS INSTITUTE OF ARTS IN MARCH 1995, AND
IN EUROPE AT THE PHOTOGRAPHERS' GALLERY, LONDON IN JUNE 1995.

Library of Congress Catalog Card Number: 94-71306

Paperback ISBN: 0-89381-636-1; Hardcover ISBN: 0-89381-599-3
Design by Susi Oberhelman and Domitilla Sartogo; Duotone separations by Robert Hennessey;
Color separations by Citiemme SRL, Turin, Italy; Printed and bound by Arte Grafica S.p.A., Verona, Italy

THE STAFF AT APERTURE FOR The People, Yes IS:
Michael E. Hoffman, Executive Director; Allegra C. D'Adamo, Associate Publisher;
Diana C. Stoll, Associate Editor; Michael Sand, Managing Editor;
Stevan A. Baron, Production Director; Sandra Greve, Production Manager;
Michael Lorenzini, Editorial Assistant; Marcy Gerstein, Editorial Work-Scholar;
Johnese R. Wilson, Production Work-Scholar

Aperture Foundation publishes a periodical, books, and portfolios of fine photography
to communicate with serious photographers and creative people everywhere.
A complete catalog is available upon request. Address: 20 East 23rd Street, New York,
New York 10010. Phone: (212) 598-4205. FAX: (212) 598-4015.

FIRST EDITION

10 9 8 7 6 5 4 3 2 1